EMILY WILDING DAVISON

EMILY WILDING DAVISON

*A Suffragette's
Family Album*

Maureen Howes

The
History
Press

First published 2013
Reprinted 2013

The History Press
The Mill, Brimscombe Port
Stroud, Gloucestershire, GL5 2QG
www.thehistorypress.co.uk

British Library Cataloguing in Publication Data.
A catalogue record for this book is available from the British Library.

ISBN 978 0 7524 9802 7

Typesetting and origination by The History Press
Printed and bound in Great Britain by
Marston Book Services Limited, Oxfordshire

Contents

I am much moved to learn that Emily Wilding Davison, a renowned name in British history and known for the self-sacrifice which helped her to win women the vote, is being remembered in her native Morpeth.

As the son of Sylvia Pankhurst I have heard her, and other veterans of that struggle, speak of Emily Wilding Davison with veneration as long as I can remember.

My warmest greetings on this historic occasion to Maureen Howes, the Davison family, Councillor Andrew Tebbutt and the people of Northumberland.

Richard Pankhurst, 2013

DEDICATION

This book is dedicated to four special people who are no longer with us:

My husband Terry, whose down-to-earth common sense for forty-seven years kept me firmly grounded.

Bill Brotherton, formerly of Morpeth and latterly of Pembrokeshire, Wales, a Caisley/Woods descendant whose extensive knowledge of the family's mining history was invaluable.

Renee Bevan of Hepscott, a Caisley/Wilkinson descendent, whose delightful, wry sense of humour made researching this book a sheer joy.

Moira Rogers of Bristol, the granddaughter of Isabella Georgina Davison, Emily Wilding Davison's half-sister. After her marriage, Isabella lived in Killough Castle, Tipperary, Ireland. Moira shared with me her family's amusement when the news broke that Aunt Emily had been discovered hiding in the Houses of Parliament.

And to the Davison/Caisley family members, who shared with me their grandparent's version of the Emily Wilding Davison story.

Acknowledgements

I WISH TO ACKNOWLEDGE the debt of thanks that I owe to so many people who have encouraged me to continue with this very special project. I am aware that without their continued support and guidance Emily Wilding Davison's – and the women of Morpeth's – involvement in the Epsom protest could so easily have been lost to our nation's historical record. Together we have shared an amazing journey, and in doing so we have changed how much-loved 'Aunt Emily' will be perceived from now on.

My especial thanks to my sister-in-law, Cynthia Claypole of Rampton, Nottinghamshire, for her loyal commitment and her genealogical skills; to Geoffrey Davison of Sydney, Australia, for his encouragement, advice, strength and kindness; Rodney Bilton of Formby, Lancashire: saying 'thank you' just does not seem enough, for his family archive opened up an unexpected window into Emily the suffragette's life; Gordon and Pat Shaw of Morpeth: thank you for trusting me with your special knowledge; Christine Telford of Morpeth and Aberdeen; Irving Rutherford of Morpeth; Robert Wood of Guidepost, Northumberland; the Bedlington/Caisley family groups, who are descended from Emily's great-uncle, Thomas Caisley: many thanks to everyone for your families' stories *re* the Caisley/Woods mining information; Professor Richard Pankhurst, who sent a message of support to the people of Morpeth and shared with me his family memories relating to Emily Wilding Davison; Dorothy Luke, Lou Angus and Sue Coulthard and their fellow members of the ninetieth anniversary tribute committee, 2002-3; to the following chairmen of the various Emily Wilding Davison committees that I have been involved with: Jim Rudd, Adrian Slassor, Mark Horton, and in more recent time, in particular Councillor Andrew Tebbutt and the committee members of each succeeding group within Castle Morpeth Borough Council, Morpeth Town Council; the Emily Wilding Davison Working Group; Morpeth's Stobhillgate Townswomen's Guild, whose membership had many Caisley/Davison present-day descendants whose local knowledge was the foundation of my suffrage research; Morpeth's Soroptimists; Morpeth's Business and Professional Women's (BPW) Foundation; the staff of Aberdeen, Edinburgh, Morpeth and Northumberland, Durham, and Tyne & Wear Library and Archive Services, all of whom at various times during the past decade have

keenly supported me in this special research project; an especial thanks to staff of Northumberland Collections Archive Service at Woodhorn; to Professor Carolyn Collette and her late husband David; Nick Hide of London and the Davison Clan Association; V. Irene Cockroft of London; David Neville; Dr Joyce Kaye of Stirling University; Dr Dorothy Pollock of Canada; Mr Bruce Gorie of the Lord Lyon's Office, Edinburgh; Mrs Bette Lindsay of Nedderton; Mr Chris Streek of the Royal Armoury, Leeds; I thank you all for the special interest and the input you have given me.

Finally, to all the present-day family members who are aware of their unique contribution: if I have inadvertently missed anyone, please accept the following family group listings to include you and your family:

Emily Wilding Davison's northern family connections (in alphabetical order): Anderson family, Simonburn, Northumberland; Anderson/Andrucci families, Morpeth and Ashington, Northumberland; Caisley/Anderson families, Morpeth and Bedlington, Northumberland; Caisley/Bilton families, Whitley Bay, Darlington, Formby, Merseyside and Epsom; Caisley/Blackhall families, Morpeth; Caisley/Waldie families, Morpeth; Caisley/Wilkinson families, Hepscott and Morpeth; Caisley/Wood families, Morpeth and Pembrokeshire, Wales; Davison/Anderson families, Alnwick and Morpeth; Davison families, Sydney, Australia, Essex and Hampshire; Davison/Hughes family, Mooroolbark, Victoria, Australia; Davison/Rogers family, Bristol; Redpath/Wood families, Morpeth.

Preface

EMILY WILDING DAVISON: *A Suffragette's Family Album* is a unique publication. With patience abounding, the careful building of trust and with integrity beyond reproach, long-time Morpeth-based genealogist Maureen Howes has brought to the surface for the first time – with the full support of the Davison and closely interrelated Caisley, Cranston, Anderson, Wood, and Bilton families and together with the peoples of Morpeth and Longhorsley – the missing story, in photographs, of Emily Wilding Davison – of her family, of her education, and of her Northumberland roots.

It disposes of the myths and misinformation created by diverse interests of the time, and fuelled by the media and highly placed Members of Parliament, surrounding an event significant in British history and in the enfranchisement of women in the United Kingdom – a right already enacted some twenty-five years beforehand in New Zealand, in 1893, and thereafter in Australia in 1903.

My great-aunt Emily Davison was indeed not a mad woman intent on pointless suicide. Nor was she an intended martyr, as frequently claimed and speculated upon by many who sadly – or conveniently – knew no better. She was a highly educated, extremely intelligent and well-connected lady, of a strong and supportive family background with a rich Northumberland heritage.

Maureen Howes has gained unrestricted access to previously tightly held records, of private family photographs, and of personal items, from which she has classically rewritten history here, with the benefit of factual evidence – not from ill-advised nor ill-informed speculation, nor from conjecture.

It is my privilege to commend this wonderful pictorially true story to all to take in, to ponder, to reflect upon, and of which to be proud.

Geoffrey Davison,
Davison Family titular head,
Sydney, Australia,
21 March 2013

The Suffragette

'Among the calamities of war may be jointly numbered the diminution of the love of truth, by the falsehoods which interest dictates and credulity encourages.'

Samuel Johnson, 1758

MORPETH, **WHERE I LIVE,** is a small market town where everyone knows everyone – in the nicest possible way, of course. I was recently in a taxi passing St Mary's churchyard, where Emily Wilding Davison was buried in 1913, when the driver said, 'You're the lady who's writing a book about "that woman" who's buried in there, aren't you?'

'Do you mean Emily Wilding Davison, the suffragette?' I answered.

In a slightly exasperated voice, the driver replied, 'But does anyone really *care* about any of that nowadays? It was so long ago.'

'Yes,' I replied. 'There are many who care about her story here in the county: her life and times are going to be celebrated here in Morpeth, and also in Epsom, on the centenary of her death, to honour her fight for equal rights. When Emily came to live in Northumberland with her mother in 1893,' I told him, 'after her father had died, she had over forty first cousins in the area – and I'm still counting! Many of their descendants from around the world will be coming to help us celebrate in June of this year.'

The driver looked at me and said, 'You've counted her cousins!'

I laughed, and I explained that that was how I had become involved in the first place: after retiring as a genealogist ten years ago, I was asked to volunteer my services in order to find her present-day relatives. The plan was to record their stories before they were lost forever.

Later that day, recalling the conversation, I realised that his opinion was also shared by many others. After researching Emily's life and times, I have come to believe that her story is just as relevant to us today as it was in 1913. However, I am the first to admit that Emily Wilding Davison has an 'image problem'. In all honesty, I admit that there was even a time when I myself shared the same view as my taxi driver (and, perhaps, as many of today's general public). After reading the above heading, you may have involuntarily exclaimed, 'Oh no! Not another

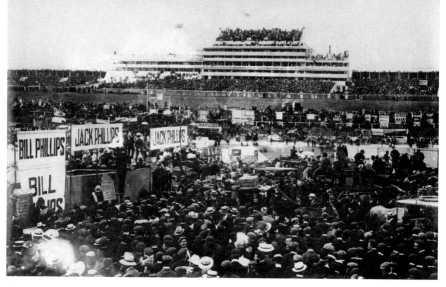

Epsom racecourse in the early Edwardian era. (George Grantham Bain Collection at the Library of Congress, LC-DIG-ggbain-08238)

version of how that woman chose to kill herself!' Or perhaps, 'There cannot *possibly* be anything new to add to her story!'

Those long-held assumptions reflect the worldwide perception of Emily Wilding Davison. They are also the reason why anyone who has dared to question the accuracy of them has sometimes been the target of similarly hackneyed responses. However, none of these assumptions about Emily are true. Samuel Johnson's famous observation (quoted on page 11), aimed at the fledgling newspapers of 1758, reflects that truth itself is the first casualty of war. This phrase aptly reflects the national headlines in 1913 after our suffragette's final protest at Epsom. How and why did truth and Miss Davison become acceptable casualties in the long and bitter fight for the women of Britain to obtain the right to vote? Whose interests were being served in the media following the death of Emily Wilding Davison, who was the fourth suffragette to be killed in Mrs Pankhurst's war of attrition against an increasingly intransigent government? I consider that this project is a work-in-progress, and I hope that others will be inspired to take up the cause after I, and my generation, are long gone, and to find the truth that lies behind every suffragette's story.

This work is a record of a remarkable family history research project, which, as it progressed, became in every sense a modern-day detective story. It revealed the closely knit ties that Emily Wilding Davison had to her wide circle of family members in Northumberland, and uncovered previously unrecorded family stories, allowing the reader to get closer to the events surrounding the suffrage movement and the protest that was carried out by Emily Wilding Davison at the Epsom Derby of June 1913, an event which ended so tragically. From this new and original material we have an opportunity to form our own conclusions, conclusions which may question the long-held views regarding Miss Emily Wilding Davison – views which have never been seriously challenged before.

The Silence is Broken

ON 4 JUNE 1913, suffragette Emily Wilding Davison was struck and fatally wounded by the King's horse, Anmer, after she ran onto the racecourse at Epsom Downs, Surrey, during that year's Epsom Derby. Pathé News had a camera running that day, and seeing the flickering black and white images they captured, showing Emily Wilding Davison stepping onto the racecourse as a group of horses thunder around Tattenham Corner, still has the power to shock today, just as it did a century ago.

Since then, many theories about Emily's intentions that day have been aired: was her act, as many have claimed, a wanton act of suicide, or did the coroner get it right when he declared that her death was a result of 'misadventure' caused by Emily 'wilfully running' onto the course while a race was in progress? Were the suffragists and the militants correct to claim that she went to Epsom as a willing martyr to the cause that she so passionately believed in? So much time has elapsed since that day, and so many claims and counter-claims have clouded the issue since, that it sometimes seems impossible that anyone will be able to uncover Emily's true intentions.

If, with the benefit of hindsight, we stop to look analytically at the headlines in the media immediately after Emily was carried off the course, and taken to the Cottage Hospital at Epsom, we will see that there were two powerful factions scrambling to gain the moral high ground in the media. Firstly, there were the strident voices of Mrs Pankhurst's Women's Social and Political Union (WSPU)'s very efficient publicity machine, never slow to take advantage of any situation that gave them column inches in the newspapers. They knew very well that the last thing the government wanted was for their movement to have a martyr around whom to rally the masses to their banner. Secondly, frantically snapping at their heels, were the government's spin doctors, men who would do whatever it took to 'spike' the women's cause – and the easiest way to do that was to deride and belittle the woman who was, by then, lying unconscious at death's door, declaring her actions suggestive of a suicidal fanatic.

Emily died four days after the collision – and the full might of the WSPU's publicity machine can also be seen in action at the funeral. One can only marvel at the logistics that must have been involved in putting the magnificent funeral

arrangements together: they were on a scale equivalent to a state funeral, perhaps comparable to the funeral of Princess Diana. What the organisers achieved, at such short notice, was nothing less than a stage-managed masterpiece. Her cortège left the Cottage Hospital at Epsom on its way to London, and processed to a memorial service in Bloomsbury.

After the service, the cortège then processed back across London, heading north aboard a special train – one which, en route, was delayed at every station by waiting crowds paying homage to the fallen suffragette. Finally, the train arrived in her ancestral home in Northumberland for a private funeral service in St Mary's church. The *Illustrated Chronicle* of Monday, 16 June 1913 reported the names of the family members in the cortège (with my research in parentheses following). They were:

First Carriage
- Mrs Davison, mother (formerly Margaret Caisley of Morpeth)
- Madame De Baecker, sister (formerly Letitia Charlotte Davison)
- Mrs Lewis Bilton, cousin (formerly Jessie May Caisley, also known as 'Mamie', the daughter of Dorothy Caisley of Morpeth and part of the Caisley/Bilton line)
- Miss Morrison, late companion of Miss Davison. (The Morrisons are related by marriage to both the Caisley/Bilton and Davison/Bilton descent lines. Miss Morrison and Emily Wilding Davison were following the family tradition of younger females becoming servants or companions in the households of older family members, as will be seen later in this book.)

Second Carriage
- Mr and Mrs Caisley of Morpeth, aunt and uncle (William Caisley and his wife, formerly Elizabeth Isabella Blackhall)
- Mr J. Wilkinson, uncle (husband of Emma Caisley, Margaret Davison's youngest sister, Caisley/Wilkinson descent line)
- Mrs H. Redpath of Ashington, cousin (formerly Elizabeth Wood, the third wife of Henry Redpath and the daughter of Robert Wood of Widdrington and Isabella Caisley of Morpeth, Caisley/Wood descent lines)

Third Carriage
- Councillor and Mrs Robert Wood, cousins (Robert Wood was the son of Robert Wood and Isabella Caisley. His wife was formerly Wilhelmina Jackson of Morpeth, Caisley/Wood descent line)
- Mr Lewis Bilton and Mrs Bell, cousins (Mr Lewis Bilton was the husband of Jessie May Caisley ('Mamie'), who rode in the first carriage. Mrs Bell was formerly Emily Wilkinson, the daughter of John Wilkinson and Emma Caisley)

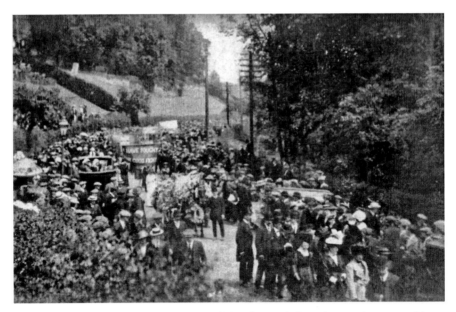

This rather battered old image shows Emily Wilding Davison's funeral procession approaching St Mary's church, Morpeth. 'I have fought the good fight,' says the banner. The *Morpeth Herald*'s report of the funeral ran thus: 'MISS E. DAVISON'S FUNERAL: VAST CROWD WITNESSES IMPRESSIVE SPECTACLE ... Last Sunday was one of the most noteworthy days in the history of Morpeth. There was interred, in the parish churchyard, the late Miss Emily Wilding Davison, of Morpeth and Longhorsley, whose exploit in stopping the King's horse during the race for the Derby on June 4 cost her her life.'

This list paved the way to the discovery of the present-day relatives of Emily Wilding Davison. Other members of the Davison line, it is believed, also attended the London and Morpeth services, though alternative travel arrangements must have been made for them.

At Morpeth churchyard Emily's mother insisted that her daughter's coffin be handed over to her family, and to her male cousins (who were her pallbearers), at the lychgate. Just three local suffragettes were allowed into the churchyard, to wait beside the Davison burial plot during the private funeral service. There they folded the hand-made banner that the Morpeth suffragettes traditionally unfurled to greet Emily every time she returned to the town: 'Welcome Home, Northumberland's Hunger Striker,' it said. Her banner was reverently laid on her coffin and interred with her. Her burial was akin to that of a soldier: she was buried wearing her suffrage medals. With her symbolic grave goods, Northumberland's fallen warrior was laid to rest with all due honour bestowed on her by the nation's suffragists, all of whom had been her comrades in arms. It was an outstanding publicity achievement, the like of which the small town of Morpeth had never seen before – nor would it see such a day again. It is possible, thinking logically, that such funeral plans were already on the WSPU's

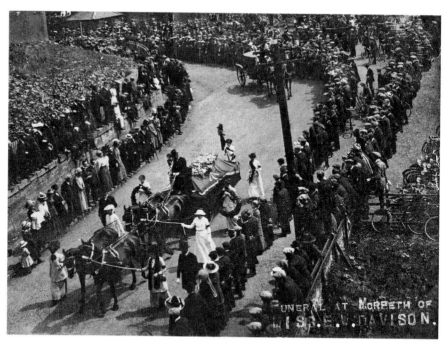

The funeral at Morpeth. (With thanks to Pat and Gordon Shaw)

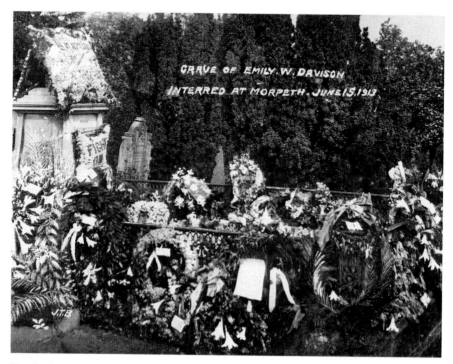

Floral tributes at Emily's grave. (Maureen Howes)

drawing board: there had been increasing fears over the frail state of Mrs Pankhurst's health. Had the militants efficiently swung into action, putting the previously conceived plans into action at a moment's notice? If so, they had pulled off the coup of a century in the process.

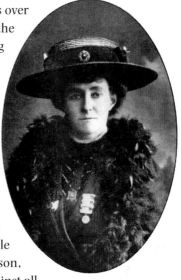

Amidst the clamour of the WSPU and the protests of the government, one set of voices remained silent: those of the suffragette's family and her closest associates. How did they respond to the unprecedented media frenzy that engulfed them after Emily's shocking injury and tragic death? With an old border tactic: they closed ranks, refusing to feed an insatiable media as a show of support to Margaret Davison, *née* Caisley, Emily's mother, and holding firm against all attempted intrusions. They (and their descendants) have maintained a dignified and defensive silence to this day, resisting the barrage of hype and hysteria surrounding the death of their much-loved ancestor. Nancy Ridley,

Emily wearing her suffrage medals. (Bilton Archive)

author of *A Northumbrian Remembers* (1970), was one person who encountered that defensive wall when she came to the area to find out more about Emily: 'There seems to be a conspiracy of silence about the Davison family in Morpeth,' she wrote. As yet, the family's side of the story has not been told – but this book, I hope, will finally give these family members a united platform of their own, allowing them to share a fascinating glimpse of the real woman behind the enigma, the woman who their parents and grandparents knew.

Research Begins

IN SEPTEMBER OF 2002, in Morpeth's County Hall, a small group of dedicated locals and county officers and councillors began to plan the ninetieth anniversary tribute to Emily Wilding Davison, which was to be held in June 2003. The results of their dedication would begin to change many of the negative attitudes surrounding the event at Epsom. The chair of the committee, Mrs Sue Coulthard, a county council officer, had instinctively known that beginning to celebrate Emily's life on each International Women's Day, as part of the service at St Mary's, would begin to bring the suffragette's image into the twenty-first century.

That was when I made my decision to become the committee's voluntary researcher and genealogist, a job which became a roller-coaster journey of discovery that would completely take over my life for the next ten years. It has been my privilege to be at the heart of this tantalizing family-history detective story as I carefully fitted together the many missing pieces. In the process I came across the unbelievable truth relating to the Epsom protest – and realised that Emily had never, in any way whatsoever, contemplated committing suicide at Epsom.

As I researched, my computer became the hub of an informal family-information exchange as long-lost Davison and Caisley descendants came to light. Together we would have many interesting email discussions. In particular, I remember one discussion with a gentleman in Australia named Geoffrey Davison. Geoffrey became one of my staunchest supporters, and he later proved to be the titular head of Emily Wilding Davison's family line. In June 2004 we discussed Emily's life, and the information I had uncovered – that Emily was an Oxford graduate with a family connected to the highest levels of society, part of a line of builders and pioneers whose influence stretched from the North East and the Scottish borders to India, Australia and even Mongolia. As he put it (and rather well, I thought), 'She was not a "nutter" ... This was not a sudden surge of blood to the head by some silly, naïve thrill-seeker. From her family and education she understood politics and ... centres of power ... Beyond anything else, she never intended to die at Epsom.'

Mrs Johnstone of Morpeth, a Caisley/Wood descendant, shares Geoffrey's views. 'Whenever I read about Aunt Meggie,' she said, 'I can never recognise

Bertie's postcard from Emily. (Bilton Archive)

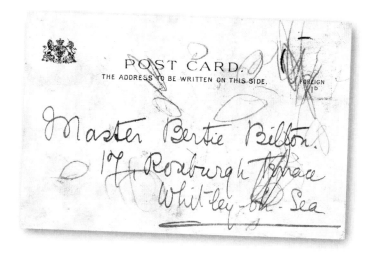

her: she had a wonderful life in the south, and they spent every summer in their shooting lodge in Aberdeenshire. Where is all that other rubbish coming from?'

Mrs Irving Rutherford, another Caisley/Wood descendant and chairman of the Townswomen's Guild, approached me at a talk and asked me to share the family's side of the story. 'We are the last generation whose parents knew Emily and her parents,' she said. 'To them she was not an eccentric historical figure: she was known to all the younger members as their very special Aunt Emily, ready at any time to take them out for a walk in their prams.' Another lady then joined the conversation, saying, 'Emily used to walk my father round Longhorsley village in his pram!' This was Mrs Marjory Watson, whose grandparents were farriers in Longhorsley. On one of my first interviews with a family member I was told about Emily wheeling one of her uncle's sons in a pram all the way across Morpeth to Bore Hole Cottage, where her Aunt Isabella (the wife of Robert Wood) lived. Emily and her mother used to give the young Longhorsley boy who swept the mud off the church path on Sunday morning pennies to thank him, because they did not want their 'Sunday best' clothes to get mud on them.

One amazing new source of insight comes from Emily herself. Emily Wilding Davison, as she grew, became an avid letter writer: whenever she was away from the North she would write to her many cousins, asking for all their news. She obviously missed their company. With the passing of time – and recurring floods in Morpeth over the years – it had been thought that all of Emily's communications had been lost. However, by a strange twist of fate, during my year as chairman of the Morpeth Townswomen Guild we uncovered some of her letters. The speaker at one of the lunches for the northern guilds, held in Darlington, was the editor of the local Darlington newspaper. I knew, from the 1913 newspaper reports, that one of the family members in the first carriage of the Morpeth funeral cortège was a cousin from Darlington, Mrs Lewis Bilton, whom I had not been able to trace. I mentioned this fact to the editor. He said he would publish a letter, if I

wrote one for him, enquiring after her. About a month went by, and I had almost given up hope of hearing anything, when I received a phone call from a gentleman from Formby, in Lancashire. 'I think you are looking for me,' he said. It was Rodney Bilton, the grandson of Jessie and Lewis Bilton; his grandmother was Emily's first cousin. He then explained that one of his university colleagues happened to be visiting Darlington a few weeks ago and had seen the paper, quite by chance, and passed it on to him. 'I am happy to copy their correspondence for you, if you wish,' he said. You can imagine my delight when a huge package arrived in the post, filled with Jessie May Bilton (née Caisley)'s postcards, all written by Emily Wilding Davison. His collection forms the heart of this image collection. Rodney also had similar stories to share, tales of his father who, as a young boy, would be taken to meet Aunt Emily's train from London to Edinburgh. It was a very brief chance for the two cousins to catch up with each other's news, and Aunt Emily would always rush to the sweet kiosk and buy 'Bertie' some sweeties before she hopped back on the train to continue her journey.

The Emily that her family knew, and who I hope this book will introduce to the world, was a vibrant and caring woman who loved

A letter to the newspapers from Emily Wilding Davison. 'Better is one wise law than hundreds of bruised and fallen victims,' she concludes.

outdoor sports, theatre, debating and writing. She fitted easily within the same literary and artistic circles as the well-known author Rebecca West (1892-1983), who, in 1913, expressed a view that perfectly expressed Emily Wilding Davison's own outlook on life: 'I myself have never been able to find out precisely what feminism is: I only know that people call me a feminist whenever I express sentiments that differentiate me from a doormat.'

One possible reason for the gap between the public perception of Emily and the family's own view might be that the few occasions on which they did speak out publically in Emily's defence went unreported. For example, in 1934 Madame Letitia De Baecker (known as Lettie), Emily's sister, wrote to the editor of the *Sunday Express* to refute a scurrilous article that had been brought to

her notice by her uncle, John Wilkinson of Edward Street, Morpeth. The editor chose not to print her letter – but thanks to the Caisley/Davison archive it can finally appear in print:

Paris
June 11th 1934
To the Editor
"The Sunday Express"
London

Dear Sir,

I have just read the article on my sister, the late Miss Emily Davison, entitled 'The suffragette who Died To Stop the Derby', which appeared in the Sunday Express dated June 3rd. It was forwarded to me by a relative who, like myself, is deeply distressed and indignant at the absolutely false assertion that my sister suffered from a malignant and incurable disease. On the contrary she had a marvellously healthy and robust constitution which enabled her to stand all that she went through. In addition she was an excellent all-round athlete.

I notice that the article states that she 'wandered about the course'.

A police official told me after the inquest that, although he was stationed almost next to her, she had darted forward so quickly as the horses raced around Tattenham Corner that he was unable to stop her.

One important item was omitted in the account, namely, that a railway return ticket was found in her purse.

With all due respect to his undeniable qualifications as a jockey, I fail to understand how Mr Jones was entitled to be considered an authority on the life and deeds of a person he had never seen till that tragic Derby day.

In spite of one's opinions regarding the methods, militant or otherwise, employed by the suffragettes twenty years ago, it seems a decided misnomer to apply the term 'fanatical' to a cause which time and events of these past years have justified and crowned with success.

In view of the incorrect statements published, and in particular the one which her family consider both damaging and libellous, I trust you will give this letter as prominent a place in your paper as the article to which it refers.

Believe me,

Yours truly,

L. De Baecker

Madame De Baecker, *née* Davison

146 bis, quai d'Auteuil.

Paris 16e.

Other family members too have memories of Emily to share – and new information to offer about her story too. During 2002-2003, to my consternation, I realised that the family's material differed greatly from the material that was publically available. What we have discovered here in the North has therefore opened up an historical Pandora's Box. The ninetieth anniversary tribute weekend, in June 2003, successfully reunited family members from across the world and throughout the UK. Some members, during the weekend, used my house as a 'second home', and as a meeting place; it became a place to compare family stories over cups of tea. Some had to sit on the floor as they learned as much as they could about their great-aunt Emily. It was in discussions such as this that we began to realise that the North's version of the tragedy at Epsom differed greatly from what many have been led to believe in the past.

In some cases, the truth about Emily has not been heard because no one has thought to seek it: the late Mrs Renee Bevan of Hepscott, a Caisley/Wilkinson descendant, once told me, 'No one has ever asked me what my mother Emily Bell (*née* Wilkinson) and my Grannie Emma Wilkinson (*née* Caisley) told us about Emily.'

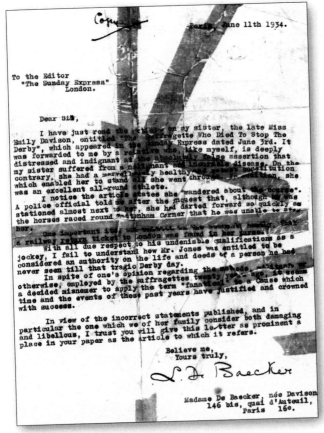

The only copy of Letitia's impassioned letter (sent to all her relatives in England) that has survived. (Bilton Archive)

The strength behind the North's version of the Emily Wilding Davison story is that it comes from the anecdotes and documentation that has been handed down through the family lines to the present generation. I am not an academic. Nor was I an expert on the subject of women's suffrage when I began this project. I knew, therefore, that I would have to be extremely careful in the way that I worked through the documentation that would back up the families' oral history and their wonderful family archive. I therefore followed the genealogist's golden rule – that every statement you publish be backed up with documentation that has undoubted provenance. This is true for the story that follows.

So just who was 'that woman' who the taxi driver knew was buried in Morpeth? And what really happened on that fatal day at Epsom?

The Early Years

EMILY AND HER SIBLINGS grew up with a clear understanding of the urgent need for social reforms. This sprang from their Davison and Anderson grandparents' backgrounds: their lives were linked to the leading politicians and reformers of their day.

The Andersons, in Earl Grey's absence, attended to the affairs of the Greys of Fallodon and Howick estates, and to their mining interests. The Davison gun-makers were of Scottish descent. They settled in the village of Milfield. Milfield village is a small rural community situated in the northern part of the county, approximately 6 miles north-west of Wooler and 3 miles north-east of Kirknewton. Josephine Elizabeth Butler (*née* Grey) (1828-1906), the feminist and social reformer, was born here. Her father, John Grey, was a cousin of Earl Grey, the Prime Minister and reformer. Here, in these remote border parishes hundreds of miles from London and Parliament, reformers such as Earl Grey – who founded the Society of the Friends of the People in 1792 – and Josephine Butler lived alongside Emily Wilding Davison's family. Their aspirations are woven together by locality, familiarity and generations of acquaintance.

In 1958, Eleanor Roosevelt addressed The Commission of Human Rights. She said:

> Where, after all, do universal human rights begin? In small places close to home
> – so close and so small that they cannot be seen on any map of the world. Yet
> they are the world of the individual person: the neighbourhood he lives in; the
> school or college he attends; the factory, farm or office where he works. Such
> are the places where every man, woman and child seeks equal justice, equal
> opportunity, equal dignity without discrimination. Unless these rights have
> meaning there, they have little meaning anywhere.

This illustrates exactly the process of how Emily Wilding Davison's social awareness developed. To discover what drove and inspired 'Emily the suffragette', you only have to look to her mother's and her grandmother's lives. These were women whose strength of character Emily and her sister, Letitia, inherited in

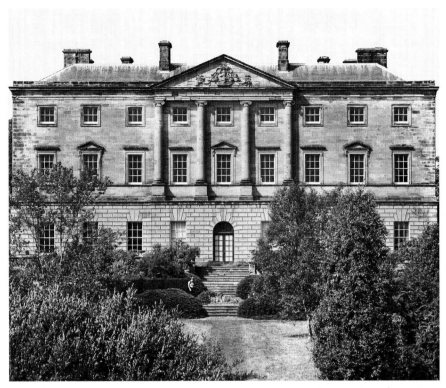

This picture shows Howick Hall and gardens, Northumberland, the home of Earl Grey. In 1801 Robert Anderson, born in 1760, was steward to the Grey household and estate at Howick. Because of the complicated Anderson, Caisley and Davison joint family roots, he was the great-uncle to both of Emily's parents. Their names were Margaret Caisley and Charles Edward Davison. (Courtesy of Lord Howick of Howick Hall)

full measure. Her female ancestors possessed backbones of steel and a gritty determination: no matter what life threw at them, they carried on unbowed.

Emily's grandmothers were first cousins named Anderson. Elizabeth married John Caisley, a mining engineer, coal owner and publican of the White Swan in Newgate Street, Morpeth. Mary married George Davison, whose first wife had died leaving him with five young boys. Mary Davison was in fact a gun-maker in her own right, and is listed in the trade directories of 1822-1838. During a conversation with the archivist at Leeds Royal Armoury, I learnt that he has cited Mary Davison in his talks on gun-makers. Her skills as a gun-maker were notable but, like many women, to succeed she had to be multi-talented: as a gunsmith, businesswoman, wife, and step-mother to her husband's five boys. She was an amazing woman. In 1827, her fortitude was severely tested when she lost her father, father-in-law and her husband, all in one year. She was nine months pregnant with her youngest son at the time, and buried her husband a week before her son was baptised.

TO BE SOLD BY AUCTION,

FOR READY MONEY,

DANIEL BUSBY, AUCTIONEER,

On THURSDAY and FRIDAY the 24th and 25th days of May instant,

IN FENKLE STREET, ALNWICK,

ALL THE

HOUSEHOLD FURNITURE

Belonging to Mrs. Mary Davison, Gun-Maker,

Consisting of Four-Poled, Camp, and other Bedsteads with Hangings, Hair and Straw Mattresses, Feather Beds, Blankets and Quilts, Sheets, Pillow Cases and Table Cloths, Mahogany Book-Case with Drawers, and a Sofa, Mahogany Tea and Dining Tables, Mahogany Hair-Seated and other Chairs, Carpets, Dressing Tables and Dressing Glasses, Wash-Stands and Chamber Ware, Pictures, a good Mirror and large Looking-Glass, Fenders and Fire Irons, Tea and Dinner Ware, Kitchen and other Tables, Pots and Pans, Knives and Forks, Silver Plate, Linen, an Eight-Day Clock, a Barometer, with many other Articles. Also all the

Stock in Trade

Belonging to the said Mary Davison,

Consisting of Double and Single Barreled Guns, Fishing Rods, Powder Flasks, Shot Belts, Dog Collars, Wadding, Copper Caps, Preserved Birds, Smiths' Anvil and Bellows, Glass Cases, Nests of Shop Drawers, Counter and Writing Desk, several Smiths' Vices, together with a large assortment of Tools for Gun-Making.

The Sale to begin at 10 o'Clock each Day.

Alnwick, May 22, 1838. G. PIKE, PRINTER, ALNWICK.

LEFT The auction poster for Emily's grandmother's possessions, put up for sale when her business as a gunsmith failed. (Maureen Howes)

ABOVE & RIGHT Guns made by Emily Wilding Davison's ancestors: a gun made in 1845 by Emily's uncle William Davison of Newcastle, and a percussion four-shot pepperbox gun made by Davison, Newcastle, England, in about 1845. (© Royal Armouries)

She continued to manage the family business nonetheless, and to care for everyone.

It could not have been easy, for her business in Alnwick soon declined. She took on a partner named Snowdon, as receipts from December 1830 show, but the partnership was short-lived, and she was left, by December 1836, to struggle on alone. Her goods and household possessions had to be sold off to meet her creditor's demands when Snowdon, her former partner, set up his own business nearby. She and her family went to live in Prudhoe Street, in the Haymarket area

~ FAMILY TREE SHOWING THE DAVISON GUN-MAKERS' LINE ~

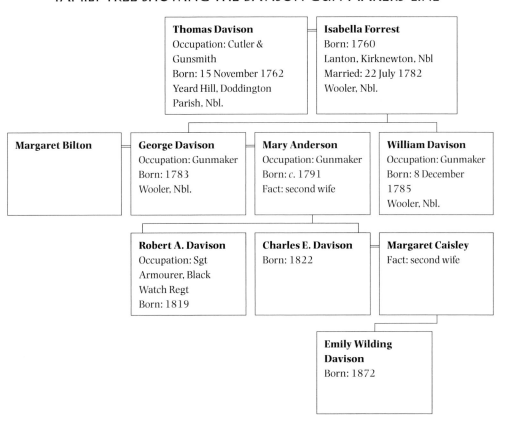

of Newcastle, to be near her brother-in-law, William, who was still in business as a gun-maker (at No. 113 Pilgrim Street). Though of necessity, her business was sold off in 1838 and she moved to Newcastle. Where she apprenticed her youngest sons in the Newcastle guilds. She and her brother Joseph, a merchant in Calcutta, then made arrangements for her sons William E. Septimus and Charles Edward's futures. All trace of Mary is lost after the 1841 census, but her three eldest sons were by then making their way in the world. Robert, the eldest, enrolled as sergeant armourer in the Black Watch in 1842; William and Charles left for India in about 1843/4; and from a letter dated 7 March 1845 – written by William Edward Septimus Davison from Meerut, to his brother Charles in Calcutta – we learn that the pair by then considered Uncle Joseph a second father.

As part of his care, Mary's brother Joseph Anderson had been able to introduce his nephews Charles and William to the leading merchants of Calcutta during their time abroad and give them a start in their new lives as indigo merchants. Charles was based in Calcutta and his brother William in Meerut, both spending

⁓ THE SETON CHISHOLM FAMILY TREE ⁓

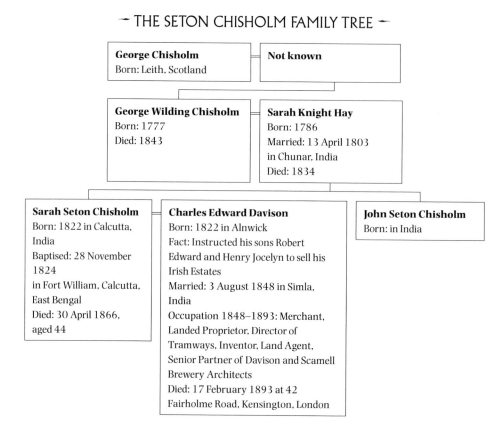

the hottest months in the hill stations at Simla. One of the leading merchants – and a close business associate of their Uncle Joseph – was John Seton Chisholm, whose father, George Wilding Chisholm, died the year before, in 1843, leaving John and Sarah Seton Chisholm a substantial inheritance.

Charles Edward Davison met the Seton Chisholms through his uncle, and he and Sarah were married in Simla on 3 August 1848. Uncle Joseph was their witness. She was a wealthy Calcutta heiress of Scots-Bengali descent, the daughter of George Wilding Chisholm and Sarah Knight Hay of Calcutta.

Their first child, Charles Chisholm Davison, was born in Umballa in 1849. Sarah's brother, John Seton Chisholm, along with Joseph Anderson, was a founder member of Simla's Freemasons, or 'The Himalayan Brotherhood'. Charles joined in 1850 and William in 1851. The minutes of this Lodge have recently been transcribed and placed on the internet, where you learn that the Lodge meetings were held when the members left Calcutta to stay in the cooler regions around Simla, the members having to compete with the noise of the bands of monkeys that overran the Lodge (causing disruption and some damage to the building). Charles and Sarah had two more sons, George William in 1851

(who died in India), and Henry Jocelyn, born in Simla in 1853. William Davison, Charles' brother, died in India in 1854. There seems to have been a joint family decision, made between Charles and his brother-in-law, John Seton Chisholm, to agree that both he and Charles should return to England with their families after this event. In 1855 Charles' first daughter, Sarah Mary, was born at No. 4 St Edmund's Terrace, Regents Park, London.

Charles Davison and Sarah prospered on their return to England. They purchased the Lavally Estates in Ireland from John Fitzgerald (the husband of their niece, Henrietta, who was the daughter of John Seton Chisholm). After the birth of Sarah Mary in London, they moved out to the Hampshire countryside, to Warblington, not far from the South Coast. Five more children were added to the family: Robert, born in Scotland; William Seton; Amy Septima; Isabella Georgina; and, finally, John Anderson, who was born in Warblington but baptised in Morpeth after Winton House was purchased and refurbished. Once the house

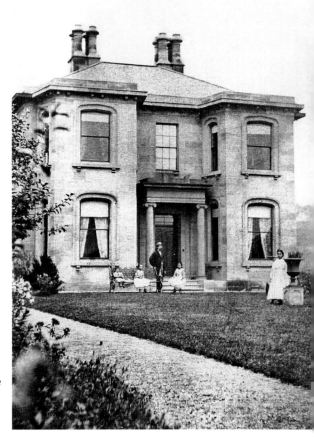

Winton House, Morpeth. Charles Edward Davison and Sarah Seton Davison (née Chisholm) with three of their youngest children in the garden of their home in Dacre Street, Morpeth. The building is now the Freemasons Lodge. Sarah died in Winton House in 1866. (With thanks to Pat and Gordon Shaw)

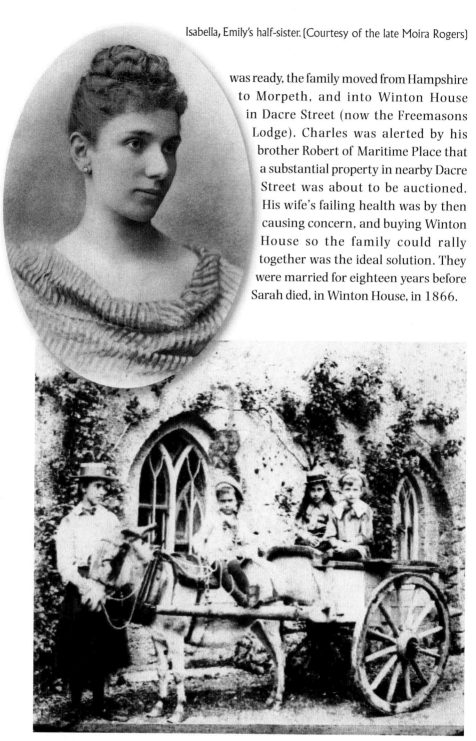

Isabella, Emily's half-sister. (Courtesy of the late Moira Rogers)

was ready, the family moved from Hampshire to Morpeth, and into Winton House in Dacre Street (now the Freemasons Lodge). Charles was alerted by his brother Robert of Maritime Place that a substantial property in nearby Dacre Street was about to be auctioned. His wife's failing health was by then causing concern, and buying Winton House so the family could rally together was the ideal solution. They were married for eighteen years before Sarah died, in Winton House, in 1866.

A family photograph of the children of Isabella Georgina Davison at Killough Castle in 1905. (Courtesy of the late Moira Rogers)

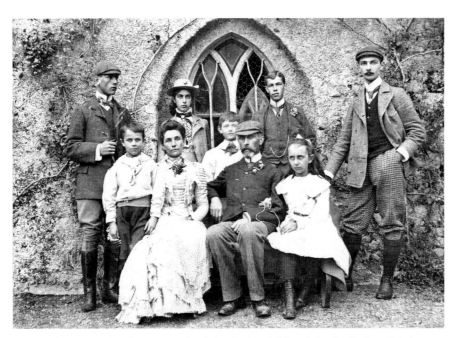

Isabella's family. Isabella is here pictured with her husband, Edward Crosbie Bayly, and their seven children — Gerald, Ethel, Lancie, Edward, Jasper, Harold and Tommie — at Killough Castle, their family home in Thurles, Tipperary. (Courtesy of the late Moira Rogers)

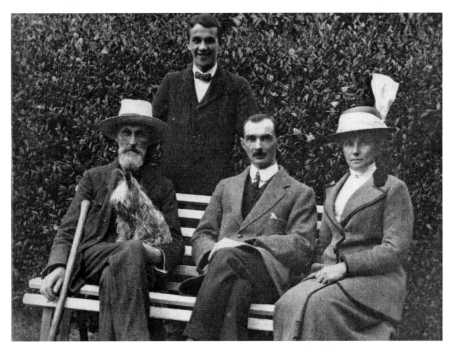

Isabella Davison's family in later years: 'Dad', her husband, on the left (with the dog), with Jasper (standing behind), Edward (sitting) and Isabella. (Courtesy of the late Moira Rogers)

The Morpeth Years

EMILY'S STORY BEGINS in Morpeth in 1864, when her mother Margaret Caisley, her father's second cousin, along with their other relatives (the local Andersons and Caisleys) and Robert Anderson Davison and his wife, Isabella, rallied around to help with settling the Davisons in their new household in Morpeth.

Sergeant Armourer Robert Anderson Davison, Emily's uncle had left Alnwick as a young man and served throughout the Crimean War, retiring from the army (after twenty-one years of service) as a Chelsea Pensioner, and coming to live in Maritime Place, Morpeth. Then he became aware of the auction of a nearby property in Dacre Street and, on 12 February 1863, his brother Charles Edward Davison purchased Winton House to be nearer his Davison and Caisley relatives, who were willing to care for his frail wife, Sarah. His second cousin, Margaret Caisley, also lived in the household with his wife and family to care for their younger children. That allowed Charles to continue with his many business ventures.

Margaret Caisley, unlike the other relatives, actually moved into Winton House with the family in order to care for the children while her elders cared for Sarah on a day-to-day basis.

Everyone celebrated the Davisons' arrival in Morpeth at the christening, on 16 October 1864, of John Anderson Davison, Charles and Sarah's ninth child; he was born in Warblington. Thanks to Gordon Shaw of Morpeth's Winton House research, we now have details of the sale and refurbishment. After the death of Thomas Jobling on 28 July 1862, his executors (who were Joseph Jobling, spirit merchant and mayor of Morpeth in 1868, and Michael Thornton, a farmer) sold the property by public auction at the Queen's Head Hotel on 7 January 1863, at 3.00 p.m. The property was described in the brochure advertising the sale (a copy of which is with the deeds of the property) as:

> ...the dwelling house situate in Dacre Street ... containing breakfast and dining rooms, library, front and back kitchens and servant's bedroom on the ground floor. Drawing room and four bedrooms on the second floor with attics above; stabling for three horses consisting of a two-stalled loose box, cow byre, coach

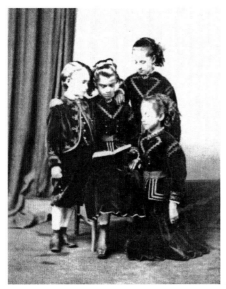 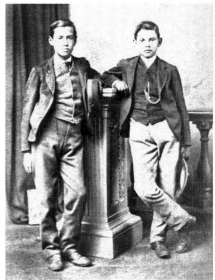

ABOVE, LEFT The Davison children. On the left is Alfred Norris Davison, aged about seven; he is distinguished by his light hair (all the children of the second family were very blonde, though the first family had darker hair). He was three years older than Emily. The girls on the right are much bigger than Alfred, so none of them can be her. (Bilton Archive)

ABOVE, RIGHT Two very dapper Davison brothers. Unfortunately, no one can now name which of Emily's half-brothers they are. (Bilton Archive)

house, dog kennel and other conveniences, together with a lawn in front and garden in rear.

The brochure was produced by William and Benjamin Woodman, solicitors. William Woodman was the first town clerk of Morpeth, and he resided at Stobhill Grange and East Riding. The highest bidder at the sale was Charles Edward Davison of Warblington House, Warblington Lane, Warblington, Hampshire, who bought the property for £1,250. The conveyance was dated 12 February 1863. At the same time, Charles increased the size of the garden by purchasing two small plots of land, 165 and 166 square yards respectively, in Howard Terrace, adjacent to the north-west corner of the property, on 12 February 1863. They were sold by George Jobling, surgeon, and William Jobling, farmer. Charles subsequently enlarged and improved the house. When Charles Edward Davison moved from Morpeth, between 1869 and 1872, Winton House was advertised for sale as 'having a croquet lawn in front, stables at the rear, three reception rooms, library, eight bedrooms and other quarters'. It was bought on 4 December 1872 for £2,000.

Although Sarah was frail, she and her husband settled into life in Morpeth. Their second-eldest son, Henry Jocelyn, attended Morpeth Grammar School. His

older brother Charles Chisholm, after boarding school, was by this time studying law, and had formed a friendship with Margaret Cranston (who also lived in Dacre Street). Margaret was the daughter of Thomas Plume Cranston, three times mayor of Morpeth. Charles Chisholm Davison and Margaret Cranston would marry in 1869.

On Friday, 21 April 1865, the *Newcastle Courant* carried an article stating that C.E, Davison, Esquire, of Winton House, and Mr James Mackay, a printer, had been chosen to supply the vacancies in the 'Four and Twenty' of the parish vestry. Messrs William Mackay, John Braithwaite, C.E. Davison and Charles Lea were elected church warden.

In 1866, Sarah and Charles agreed to become the guardians of a young orphaned girl, the daughter of an officer in the Indian Army that they knew from their days in Calcutta. She joined the family on the death of her father, Major Corfield of the Indian Army. She was the same age as their daughter Amy, and the two quickly became inseparable. Jessie was brought up as 'one of the family', with the additional help of Margaret Caisley, who was a loving and caring young woman with past experience of 'keeping house' and caring for the children within her older sister's household at Widdrington. The Caisley/Davison family relationship made it easy for Margaret, Sarah and the children to become a close family unit, and with numerous other Andersons and Caisleys in and around Morpeth, the family had many sources of support to call on when needed.

Sarah passed away on 29 April 1866. She was the first to be buried in the Davison burial plot in the local churchyard.

Margaret then became a mother figure to the household, and over the next two years the care she gave his children naturally forged a strong bond, which blossomed into a loving relationship between her and the widowed Charles. Their first child, Letitia Charlotte, was born out of wedlock on 15 February 1868 at Bar Moor in Ryton, County Durham. She was registered under the name of 'Dawson', a Davison clan sept name (a division of the family) and a variation on Davison (the Scottish name 'Davidson' in Emily's family line lost the middle letter 'd' in the English parish records).

She was then baptised in Ryton Parish under the name of Davison, and Charles gave his residence as Bath. Mrs Pat Shaw of Morpeth, a Caisley/Wilkinson descendant, once said, at a family get-together, 'I remember once seeing a christening mug with the name "Letitia C. Davison" on it at grandmother's house.' The grandmother in question was Emma Wilkinson (*née* Caisley), who was with her sister Margaret Caisley in Longhorsley when she died in 1918. Margaret and Charles were married by licence on 3 August 1868 in St Alphege, Greenwich, Kent.

Margaret and Charles' second child, Alfred Norris Davison, was born in Winton House on 27 May 1869. Charles' business affairs were mainly in the

South, so to solve the problem Winton House was advertised for sale and the family moved to Ealing – where they are recorded in the 1871 census in Ealing's Christchurch district at Mattock Lane. They called their Ealing property 'Winton House'; their property in Morpeth did not sell until 4 December 1872.

The 29 September 1875, at St Nicholas' church, Newcastle, saw the marriage of Sarah Mary Davison (aged twenty), of Dacre Cottage, Well Way, Morpeth. Sarah was Emily's half-sister, and may have remained in the North when the family moved south. As noted, the family home, Winton House, was not sold until a few years after the Davisons' move, and it is possible that she had remained there with the resident servants. Her father could have arranged for her to live in Dacre Cottage thereafter. The groom was John James Robins, of Falconer Street, Newcastle. He was a medical student, and the son of William Robins, a pawnbroker of Newcastle. After the wedding, the pair seem to vanish from Morpeth and Newcastle, with no further mention of them in the family or within any documented evidence in the archives.

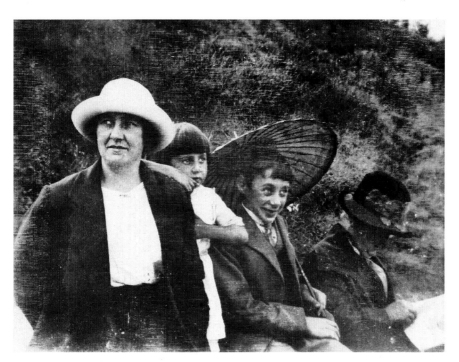

Emily Bell (*née* Wilkinson), Emily's cousin, with her children. The elderly lady reading, on the right, is Emma Wilkinson (*née* Caisley), Margaret Caisley's sister and Emily's aunt. Emily Bell's daughter grew up to become Mrs Renee Bevan, and her son was Pat Shaw's father. (Caisley / Wilkinson Archive)

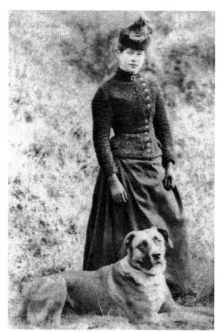 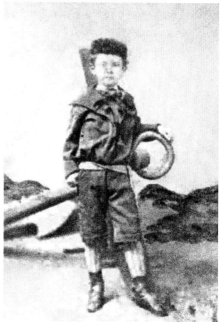

ABOVE, LEFT This smart young woman is thought to be Margaret Caisley, the mother of Emily Wilding Davison. (Bilton Archive)

ABOVE, RIGHT Alfred Norris Davison, born on 27 May 1869 in Winton House, Morpeth. He was the son of Margaret and Charles Davison, and full brother of Emily Wilding Davison. Both this image and the photograph of Margaret above are from the Bilton collection. After much discussion, the present-day family members pointed out that he is wearing a hat made of the same material as the jacket she is wearing. That was typical of the Caisley thriftiness, and is as good as a signature in their eyes: it must be Margaret! (Bilton Archive)

The census lists them with their youngest children, Letitia, aged two years, and Alfred, aged one year. There were also six other children, aged between seven and fifteen, in the house, all from Charles' first marriage to Sarah Seton Davison (*née* Chisholm). The older children were: Sarah Mary; Robert Edward; William Seton; Amy Septima; Isabella Georgina; and John Anderson Davison. Another family member lived at the house, as mentioned: their ward, Jessie Stuart (also referred to at times as Jessie Davison). She was eleven at the time of the census. A niece, Isabella Chisholm (aged seventeen), born in Calcutta, India, was also with the Davison family at this time. The household staff at this year consisted of a footman, a nursemaid, a housemaid, a cook, and a nurse – making a total of seventeen people living in their household.

Three of Emily's brothers would go on to have very successful careers in the navy, army and law, while the others were encouraged by their father to take an interest in his inventions: letters patent show that C.E. Davison entered patent No. 4938, dated 11/11/1881, for a tramway-braking system. Henry Jocelyn

Davison's obituary in *The Chronicle*, of Bexhill-on-Sea, printed on Saturday, 7 February 1914, describes him as an 'inventor', whilst John Anderson Davison's Canadian Overseas Expeditionary Force attestation papers of 22 May 1916 also give his occupation as 'inventor'. All of the brothers helped to manage and supervise their father's many commercial enterprises in the UK and abroad, and with the stewardship of the family estates in Ireland.

Then, on 11 October 1872 in Roxburgh House, No. 13 Van Burgh Park Road West, in Blackheath, near Greenwich, a child named Emily Wilding Davison was born.

Roxburgh House was her parents', Charles and Margaret's, London town house. Emily was the third of four children – and her father's twelfth child (Charles had eight surviving children with his first wife). The Davisons were a large and loving family, and their children were encouraged to participate in sports and music and, most of all, to enjoy everything that they attempted, making them resilient, confident and outgoing high-achievers in whatever fields they chose to follow.

ABOVE, LEFT Unfortunately, no childhood pictures of Letitia have survived because of the recurring Morpeth floods. Here we see a smart and self-assured woman, using the photograph to send her greetings to her cousin Mamie (Jessie May Bilton, *née* Caisley). (Bilton Archive)

ABOVE, RIGHT Christening gowns of the Davison children, one for the boys and one for the girls (which Emily would have worn). Mrs Renee Bevan rang my doorbell carrying a plastic carrier bag and asked, 'Do you want to see Emily's christening gown?' You do not get any better moments than that when doing new and original research: she made my day. (Caisley/Wilkinson Archive)

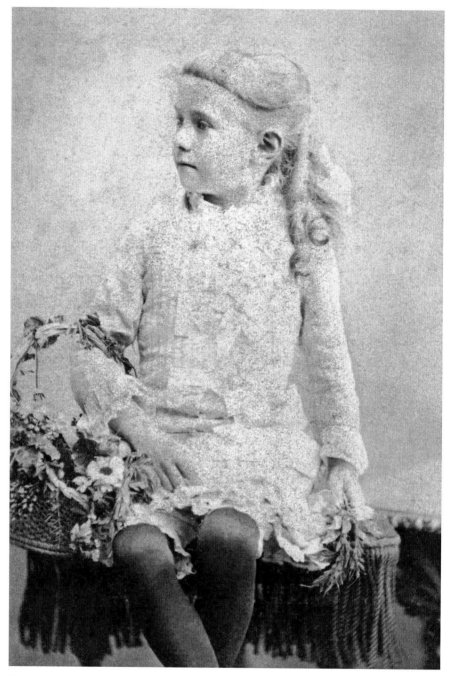

Emily Wilding Davison at seven. She was then a pupil at the School of Lausanne in the premises of William Fenwick at Russell Square. (Bilton Archive)

Emily herself would excel in, and revel at, her sporting activities. She was also artistic, with a great love of theatre and drama. Most crucially, the family instilled in their children a sense of social responsibility, a sense that they had to be aware of the needs of others and that they should recognise – and be prepared to fight for – much-needed social changes in society. A Davison descendant, Moira Hughes of Mooroolbark, Australia, shared on a Northumberland visit some of the stories her grandfather would tell them. These illustrated their sense of social awareness. He was William Seton Davison, born in 1858 in Warblington, Hampshire. He was Emily's half-brother, and spoke of the times when Letitia and Emily would accompany Margaret Davison on her trips to deliver food parcels for the soup kitchens where they worked as volunteers in London's East End. These parcels were usually for the dockers' wives and children – and were obviously remembered, as there is evidence that dockers in the crowd shouted down others who jeered as Emily's funeral cortège passed through London in 1913.

The property in Blackheath where Emily was born was probably bigger than the house they were recorded at the year before, when the 1871 census return was taken. The move to Greenwich would have accommodated their expanding family and the imminent birth of Emily, perhaps with an attendant need for more household staff.

New Jobs, New Houses and the Loss of a Beloved Sister

O N 1 MAY 1879, when Emily was nearly seven, the family took on a lease at Trentham House, Riverdale Road, Twickenham. It was to be a very sad and difficult time for the family.

The houses on Riverdale Road were leased to families who, like the Davisons, had members who had been merchants in India or those who had served in the Indian Army. It was considered to be a select residential area, and was everything that any upwardly mobile family could have wanted. Having neighbours that fitted in with Charles' background, and his experiences in India, was a delight, and the overall impression given by the respectable-looking houses in the Riverdale Road area was one of Victorian affluence and solidity, with no hint of the underlying problems soon to make themselves known.

As time went on, however, concerns began to emerge. Shoddy workmanship meant that in a few months the building was pervaded by the miasma of untreated sewage: the drains would not take the effluence away, and so the basements overflowed with raw sewage. In desperation, Charles Davison complained, in writing, about the situation, asking to be released from the contractual term of his lease. However, it was already too late: in July 1879, four of the Davison children became seriously ill with diphtheria. This outbreak was attributed to 'bad drainage', and to the 'offensive smells' that pervaded the house. Ethel, the youngest, born at Roxburgh House, Blackheath, on 9 July 1874 and aged just six, did not survive. Her death was reported in *The Times* on Wednesday, 22 December 1880.

The family arranged for her to be taken back to Morpeth, where she was buried in St Mary's churchyard. Ethel would not be the last to make that sad journey. Reading the reports of the court case that followed on 22 December 1880, you cannot help but be moved by the situation that the family had found themselves in. Charles and Margaret were understandably distraught, and a lengthy but ultimately unsuccessful six-day court case was brought against the builders and developers. Though witnesses declared in court that Ethel's death was directly attributable to the conditions in the house, the court case was not settled in the Davison's favour, though they were freed from their lease of a building now tainted by tragedy. From the details on Robert Edward's marriage certificate in

On 1 May 1879 the Davisons leased Trentham House in Riverdale Road, Twickenham. (Courtesy of Nick Hide of the Clan Davidson Association)

June 1880, we learn that the family were already living at No. 26 New Park Street, Windsor, by this point.

Nick Hide, of the Clan Davidson Association, kindly went exploring for me in Twickenham's Riverdale Road. He spoke to one of the residents, and discovered that they still had the original deeds to the house next door to the Davison's home. These deeds specified the tenants' links to India.

Some of Emily's siblings had, by this time, begun to marry and leave home. Robert married a Scottish girl called Margaret Emma Munro Ross from Ross and Cromerty. In June, Amy Septima married John Briscoe in Edmonton. By this time Jessie Stuart/Corfield, the family's ward, had already married George Briscoe. As befitted the closeness of her relationship with Amy, Jessie's husband was the brother of Amy's husband.

In 1881, Henry, by then a young naval officer, was presented to the Prince of Wales at court (by the then Duke of Edinburgh).

During the years 1881 to 1888, Charles Davison held a number of tramway directorships (with his sons Robert and William), managing and supervising the running of his tramway interests in several different companies: Derby Tramways Ltd; the Sheffield Tramway Co.; the West Metropolitan Tramways Co.; the South Staffordshire and Birmingham District Steam Tramways Co. Ltd; the Birmingham Central Railways Co.; and even a Swedish connection, the Gothenburg Tramways Co.

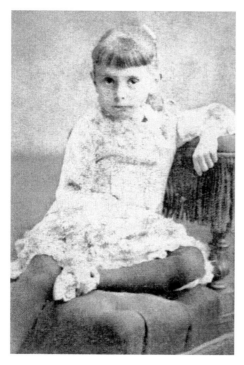

Ethel Henrietta, Emily's sister. It is possible that the two sisters, Emily and Ethel Henrietta, are wearing the outfits made for them for Isabella Georgina's marriage on 15 August 1878. Ethel died, at the age of six, on 24 July 1880 at Trentham House, Riverdale Road, Twickenham. The cause was diphtheria. (Bilton Archive)

He was also busy with his inventions. *The Times* of Friday, 20 April 1883 lists the 'Alteration of part of the specs of the invention, Letters Patent No. 4938, 11/11/1881':

In the Matter of Letters Patent Granted to Charles Edward Davison of Bedford House, Stamford Hill, Middlesex, Gentleman, for the invention of 'Improvements in apparatus or appliances for stopping and re-starting tramway cars and carriages, and other like vehicles, bearing date 11th November 1881, No. 4938'. Notice is here given that the said Charles Edward Davison has applied by petition to the Commissioners of patents of invention.

The family, locally, grew during this era, and Emily's first nephew is recorded at Morpeth Grammar School at this time, on 23 December 1885 being awarded the 'Special Prize for Music'. By the end of the decade, Henry Jocelyn was a naval officer on HMS *Euphrates*.

Emily as a Child and a Young Woman

WHAT SHAPED THE character of the young Emily? Her parents and her closest family were obviously the strongest influence, but perhaps her school companions played a part. Finding anything from her younger days was, I thought, going to be difficult. However, I was then presented, out of the blue, with some rare documents from Longhorsley. These had been saved from Margaret Davison's garden bonfire in 1918 by one of her neighbours. Mr and Mrs Jeffrey, of Morpeth, rang me to say that their parents and grandparents had owned The Shoulder of Mutton public house in Longhorsley at the time that Margaret Davison lived across the road. Could they call and see me to show me something that had belonged to the Davison family? Their name, and the location of Longhorsley, was significant. The census returns of Longhorsley listed the Jeffreys as the local publicans, living opposite Emily's mother's corner shop. We sat in my garden potting shed, drinking cups of tea, while they explained their unique relationship to the Davisons and the Caisleys. Mr Derek Jeffrey explained that his father, as a young boy, had been Margaret Davison's handy man-cum-gardener. His wife, Eileen, was descended from Margaret Davison's youngest sister Jane Caisley, who was born in 1853 in Morpeth and who had married John Waldie. According to the Jeffrey's family story, the young gardener had realised that Mrs Davison was not at all well shortly before she died in 1918 – in fact, she seemed to be quite upset. One day, when the garden bonfire was ablaze, Mrs Davison came out of her house with lots of papers and asked the young boy to burn everything for her. He could see that some of them were private papers and books, one a scripture book and a birthday book. Being a young lad who had been taught to respect such things, he could not bring himself to do it. Instead, he took them over the road to his parents' house to ask their opinion. One of the items was young Emily's birthday book. In it she wrote down the birthdays of, and names of, her family and friends. I carefully transcribed the names and thanked Mr and Mrs Jeffrey for their kind help with my project.

The first list of names obviously records family names:

Robert E. Davison (her brother, born in Laurencekirk, Kincardineshire)
Amy S. Davison (her sister, born in Warblington, Hampshire)

William Davison, 1838 (unknown)

William S. Davison (her brother, born in Warblington)

The remaining names were probably her friends' names. They are:

Bertha Clark; Annis Dawe; Edith M.J. Lloyd, 1872; H. Christiana Severn; Nellie Cummings, 1874; Dorothy Giles; Emily P. Story; Daisy Nicholson, 1872; Katherine Scott; S.M. Taylor; Lillie T. Cameron (may be an 'S' or a 'T' for the initial); Arthur S. John Carter; A. Baxter (or Barter) White; Agnes M. Hitchcock.

Who were they, these people whom Emily had carefully entered in her special book?

Professors Carolyn and David Collette from Massachusetts now enter the story: they were in Morpeth's library one day, asking for any information the librarian had regarding Emily Wilding Davison. The librarian rang me immediately. I invited them to come up to my home, and that was the beginning of a wonderful friendship. Carolyn's field of expertise is medievalism and the works of Chaucer. She was convinced that Emily was a student of Chaucer from certain medieval terms used in Emily's letters to the *Morpeth Herald*, and from certain letters signed 'Faire Emelye'. (Faire Emelye is a character in *The Knight's Tale*.)

In 2012, Morpeth Soroptimists were contacted during an event by the great-niece of two of Emily Wilding Davison's schoolfriends. Her name was Irene Cockroft, and we spent a delightful two days discussing her great aunts' schooldays. Their names were Ernestine and Emily Bell, and wonderfully their story sheds light on the moniker 'Faire Emelye'. They, like Emily, would become suffragettes. The story that has been handed down in Irene's family is this: that Emily Wilding Davison had played the part of Chaucer's Faire Emelye in a school play (adapted from Mrs Haweis' book *Chaucer for Schools*), and that from that day on her schoolfriends called her the same (partly to distinguish her from Irene's great-aunt Emily, who was dark-haired). Ernestine married Dr Herbert Mills and became a distinguished enamellist who designed suffragette brooches and badges. Ernestine also designed the first London Soroptimist badge.

Irene Cockroft brought her original copy of Mrs Haweis' book with her. Inside is a drawing, 'Faire Emelye picking flowers', and from this picture, and the play, grew Emily's passion for Chaucer.

There were to be still more surprises for me before Irene left. She told me more about Ernestine's fabulous artwork, and that Ernestine had in fact created an enamelled icon of Emily, shown as a Joan of Arc figure. She has generously allowed me to use it in this book, saying, 'Here, Emily wears a celestial blue cloak among Madonna lilies, symbolising purity and chastity. There are colour notes of purple, white and green, the colours of militant WSPU suffragettes. Small

The 'Faire Emelye' enamel on plaque, c.1914.
(© Ernestine Mills (1871–1959); image courtesy of
V. Irene Cockroft; photography © David Cockroft
2000)

marks on the cloak indicate fleur de lis, symbolising that 'Faire Emelye' has adopted the cloak of St Joan [of Arc]. The enamel image surround is copper or bronze.'

To discover more about Emily's schooldays, I contacted the staff at Kensington High School for Girls, who were surprised and delighted to learn that Emily was one of their old girls. Indeed, they focused their Founder's Day celebrations, on 25 January 2013, around a suffragette theme, and several of Emily's relatives attended. The staff at that school then sent on an email from Becky Webster, Deputy Archivist of the Girl's School Trust at the Institute of Education, University of London, sharing more about Emily's schooldays through their records:

Date Enrolled: 3 November 1885
Parent: C.E. Davison of 7 Nevern Road, Earls Court
Former school: School of Lausanne at the premises of William Fenwick, Russell Square
1889: [distinction from] the College of Preceptors (probably their secondary examinations for pupils)
1889-1891: The Higher Certificate
Date of leaving: July 1891

Details from the logbook:

Page 59: Emily is listed as completing the College Preceptor's examination in 1890 (Passed Class II – Division II)
Page 71: Passed the drawing examination, summer of 1887 (Division II)
Page 76: Marked as 'H' (meaning honours), drawing examination, summer of 1888 (Division III)
Page 81: Honours, drawing examination, summer of 1889 (Division IV)
Page 85: Honours, drawing examination, summer of 1890 (Division V)
Page 99: Prizes for English, French and Latin in 1889

Page 101: Prizes for French and Latin in 1890
Page 103: Prizes for English and French in 1891
Page 104: Gained the complete Higher Certificate, passing scripture, French (with distinction), German, elementary mathematics, literature (with distinction), and drawing in 1891. This is the most subjects of any of the girls listed – drawing being the additional subject.

What a fascinating glimpse of Emily the young woman, here just two years before her father's death and a move to Northumberland.

In 1891, Emily began her September term at Holloway College. Six months later, another difficult time for the Davison family began with the announcement of the divorce of Emily's sister Amy Septima on 30 July 1892. Amy Septima Briscoe (*née* Davison) and her husband, John George Briscoe, came to court in *Briscoe versus Briscoe*. It is probable that Amy Septima would not have had any means to pay the costs of the divorce. Though her husband was himself not above blame, the fault was placed on Amy's side: her husband was robustly pursuing the case after he discovered that Amy had had a weekend dalliance with a gentleman friend in Haslemere. Though Charles E. Davison was in no way liable for the costs of Amy's divorce, it is possible that the family, to save face, rallied around Amy and met her costs. The distress and upset caused when Amy's marriage ended – in what was to become an extremely messy divorce – took its toll on her father's declining health, and also on his finances. This would have left an indelible impression on Emily, especially as regards the rights of women to own their own property, at a critical time in her life. Amy was left near-destitute, with three children to support. William Seton's descendant Moira Hughes, of Australia, revealed (during the 2003 weekend) that her great-aunt Amy had been totally dependant on the first family's siblings' hospitality and support after the divorce: she relied on extended visits to their households to survive.

The situation became even more difficult on 7 February 1893, when Emily's father died. At the time of his death, his family were living in Fairholme Road, West Kensington. However, as the house was way above the means of Margaret, his widow, she and her children were forced to move out, at least until their financial affairs could be improved. It is believed that they moved to the address given in 1895 on Letitia's marriage certificate, though no precise date has ever been discovered for when Margaret moved back to Northumberland, nor when her son Alfred Norris went to Canada (where it is thought he may have joined his half-brother, John Anderson).

The day after the will was probated, on 14 March 1893, the significance of the family's finances began to sink in. Under the terms of Charles' will, Margaret was the sole beneficiary. For her own use and benefit, she was left £102. The witnesses to the will were Florence Every Clayton, Spinster, of Carr Hall, Nelson,

The music award of Charles Cranston Davison, who was born in 1870 in Hull, Yorkshire. He was Charles Edward Davison's first grandchild and the son of Charles Chisholm Davison and Margaret Davison (*née* Cranston), the daughter of Thomas Plume Cranston. Charles Cranston's grandfather on his mother's side was three times mayor of Morpeth. (With thanks to the Geoffrey Davison Archive, Australia)

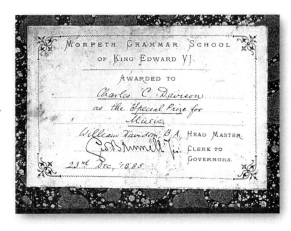

Lancashire, and Joanna Ross, Spinster, of Coul Cottage, Alness, Ross-shire. There is a letter, from a relative's home in Morpeth, written by Emily on 15 February 1893. In it she expresses her growing concerns. She is leaving the next day, she writes, on the instructions of her mother and with the help and support of her Caisley aunts and uncles:

> Mamma has decided that I am to return tomorrow to college. It is very hard to leave them all, but what can I do? Mamma has to pay 20 pounds a term for me, and it must not be wasted. I do not know whether I can stay after this term, as we do not know how matters are yet, so I must make the best of this term. Mamma is very anxious to keep me at college for my exam if it is possible. (John Sleight, *One Way Ticket to Epsom*)

We should never underestimate the determination of mothers like Margaret and Dorothy Caisley. They moved heaven and earth to support their daughters, Emily and Jessie May. In the Bilton Family Archive you may find a scrap of paper written and signed by Dorothy Caisley, who was the keeper of the Caisley mining accounts. In it, she has recorded the finances involved in opening Hepscott Colliery, as well as the sinkers' wages and an advance for a share of Hepscott Colliery. The paper is undated, but the Northumberland mining records in the archives confirmed that the work on the Hepscott Colliery was in the same timeframe as the death of Charles Edward Davison.

Lent to my sister Davison:	£20
Lent to my brother for Hepscott Colliery:	£57 19s 2d
Lent last December for the sinker's wages:	£40
Want from my brother, which was left to me from my mother:	£20
Advanced for a share of Hepscott Colliery:	£95
Dorothy Caisley	

Lent to my sister Daisey 1 0
20
lent to my Brother for
Hepscott Colliery 54 - 19 - 2
lent up to last
for sinkers wages 40

wants from my Brother 20
which was left by my
Mother

advanced for a share
of Hepscott colliery 95

Dorothy Caisley

LEFT The scrap of accounts left after Emily's father's death. (Bilton Archive)

BELOW Bedlington / Caisley's family history has it that the Caisley's family's pit, sunk by John and Thomas Caisley at Hepscott, was in fact at Barmoor. Anne Findlay of Hepscott Heritage Group also said that Barmoor pit was sunk in 1893, and the pit named in Hepscott Heritage Group's chart was sunk much later. (Courtesy of the Hepscott Heritage Group)

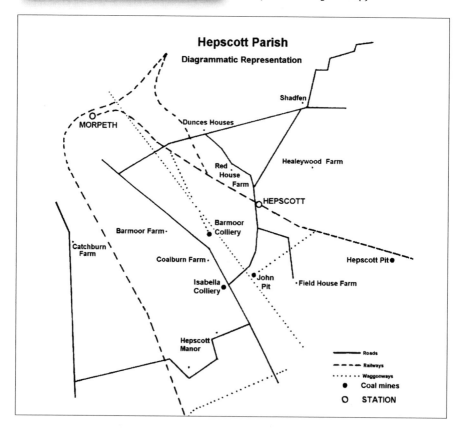

Hepscott Parish
Diagrammatic Representation

Shadfen

MORPETH

Dunces Houses

Healeywood Farm

Red House Farm

HEPSCOTT

Barmoor Farm

Barmoor Colliery

Catchburn Farm

Coalburn Farm

Hepscott Pit

Isabella Colliery

John Pit

Field House Farm

Hepscott Manor

——— Roads
– – – Railways
········· Waggonways
● Coal mines
O STATION

Charles Davison died in February, so we can deduce that she was returning to finish the spring term. Courtesy of Professor Caroline Collette, who has collated the writings of Emily Wilding Davison, we know that Mrs M.E. Bishop, principal of Holloway, wrote her letters of recommendation in June of 1893: 'that she had completed five terms there, but had to leave because of family circumstances.'

The Caisley Mining History:
Collieries, Castles, Aristocrats, Sudden Deaths and Suffragettes

Giuseppe Garibaldi, the man who united Italy, was also a mariner. His main cargo was coal from Newcastle, and when docked at Tynemouth he would debate the issues of the day with the local coal-owners and the radicals and reformers of the North. He supported women's suffrage, and the suffragists of the UK in turn raised funds for his reforms in Italy.

The Caisley side of Emily's family, John Caisley and Elizabeth Anderson, the grandparents of Emily Wilding Davison, had links to the coal industry. They moved around the Morpeth area because of the Caisley mining interests. In 1871 they were living at Needless Hall, River Greens. John worked with his brother Thomas Caisley of Bedlington and his son-in-law, Robert Wood, as mining engineers and colliery owners. Their sons in turn managed the mines.

John Caisley's Quarry Drift Coal Company
Courtesy of the late Mr Bill Brotherton of Wales, we can share this letter from John:

Morpeth
August 22nd 1872
To the Mayor and Council of the Borough of Morpeth.

Gent.

I beg to make an application to you to allow me to erect a bridge over the Wansbeck at the Quarry for the accommodation of the Colliery which I have opened there and as it will have to come upon your property at 'Hardy's Hole' I wish to have your leave to pass to the turnpike by paying a reasonable acknowledgement for the same.

Yr. Obt.
John Caisley

The Caisleys and Woods were absorbed in coal mining. 'As a young boy I remember when two or three of them got together that's all they talked about'. My grandfather [Charles Edwin Wood] had a set of bore rods which were manually forced into the ground to find

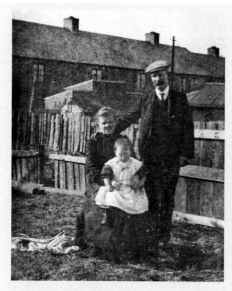
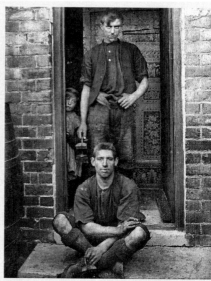

ABOVE, LEFT Thomas Caisley with his wife Sally and daughter Hannah. (Courtesy of the Bedlington Caisley / Woods Archive)

ABOVE, RIGHT Joe, Jack and Hannah Caisley, who helped to run the Caisley mine. Thomas was the brother of Emily's grandparent John. (Courtesy of the Bedlington Caisley / Woods Archive)

BELOW, LEFT Hannah Bussey (*née* Caisley). (Courtesy of the Bedlington Caisley / Woods Archive)

BELOW, RIGHT Wilhelmina, the foster daughter of Margaret Caisley, with Hannah, Thomas's daughter. (Courtesy of the Bedlington Caisley / Woods Archive)

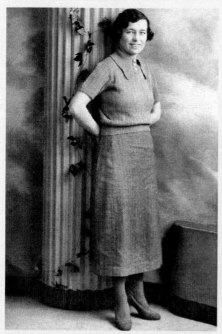
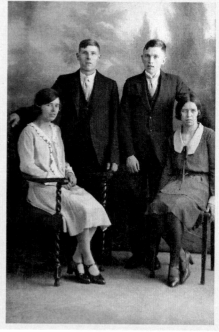

Jacob Caisley and his wife, Marion. Jacob is the son of Thomas Caisley. (Courtesy of the Bedlington Caisley / Woods Archive)

coal or water. They bored so many holes around the Northern areas that they knew exactly where the coal seams were located. Of course in those days it was the quality and depth of the seam that was the criteria, as workers had to be able to crawl through to work the coal – it sounds terrible, but I can honestly say that it was no deterrent to them. I would think that Lynmouth Colliery would rank as one of their most successful [pits].'

In 1874 the Caisley family were owners of Chirm Pit and Bushy Gap, Rothbury. In that year three children were born there, all first cousins of Emily Wilding Davison. In November 1874, Elizabeth Caisley was born at Bushy Gap. She was the daughter of Thomas Caisley, coal owner and uncle to Emily Wilding Davison. A few months later, in December 1874, Ethel Waldie was born at Bushy Gap. She was daughter of Jane Caisley and John Waldie.

Finally, Emily's much-loved cousin Jessie May (Mamie) was born there in 1874. Her mother was Dorothy Caisley, and her birth highlights the plight of many young women who were working in service in the big country houses. Dorothy Caisley was an older sister to Emily's mother, and was working, at the time of Mamie's birth, in service to one of the titled families. There, she was 'compromised' by an upper-class young man, resulting in the birth of Emily's cousin Jessie. (That family experience, in turn, may have influenced Emily in her fight for women's rights and the need for women to have a voice of their own.) Mamie was the illegitimate daughter of Mr Robert Trotter Hermon-Hodge of the Hodges of Newcastle-upon-Tyne. Robert Trotter Hermon-Hodge (1851-1937) was MP for South Oxfordshire twice (1895-1906 and 1917–1918) and for Croydon too (1909-10). He became the 1st Baron Wyfold of Wyfold in 1919. Robert did support his daughter, albeit in his own way: Jessie's grandson Rodney Bilton shocked and surprised me one day by sharing the family's story of how Robert Trotter Hermon-Hodge would ride past the Caisley's house in the country and

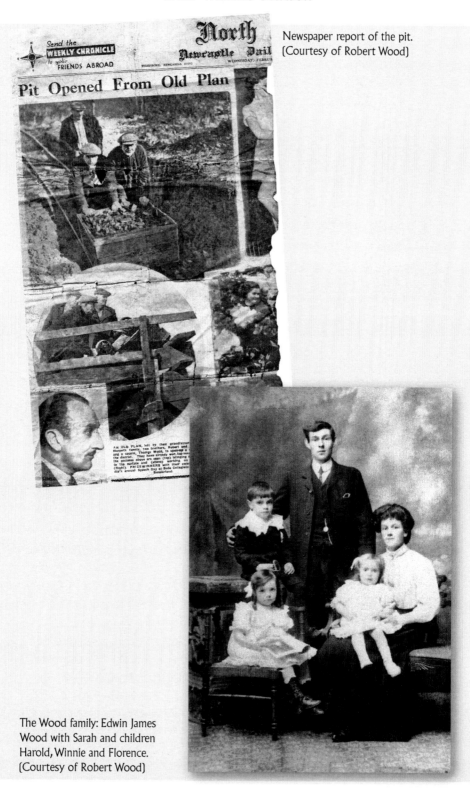

Newspaper report of the pit.
(Courtesy of Robert Wood)

The Wood family: Edwin James
Wood with Sarah and children
Harold, Winnie and Florence.
(Courtesy of Robert Wood)

LEFT Baron Wyfold, Mamie's father.

BELOW The last will and testament of Emily's Aunt Dorothy, leaving everything to Jessie May.

LORD WYFOLD of Accrington, who achieved fame in the House of Commons and in the Lords for the length of his moustache, which reached the lapels of his coat. He has died at Wyfold Court, near Reading, at the age of 85. He was the eldest son of the late Mr. G. W. Hodge, of Newcastle.

BELOW Mamie with Lewis, Basil and Lesley. (Bilton Archive)

casually toss two sovereigns over the hedgerow for Jessie's upkeep. He would then ride on. Rod's grandmother, as a child, was often cared for by her grandparents, Elizabeth and John Caisley. To be fair to him, we should now add that when Jessie married Lewis Bilton, after her mother's death, the baron bought them a small terraced house in Newcastle. Another twist in the story (one which appeals to me as genealogist) is that when Rodney's father was researching his grandfather's family line he realised that the 2nd Baron Wyfold, Roland Hermon Hermon-Hodge, married Dorothy Fleming, the aunt of Ian Fleming (of James Bond fame). Ian's brother Peter Fleming married Celia Johnson, the actress.

The family must have been in a state of shock after Charles' death. The financial situation did not improve for some time, leaving the family with a question: where had all the money gone to? There has been much speculation on that score. We now suspect that Charles Edward Davison's finances had been seriously depleted by the costs of the two court cases he had become involved in towards the end of his life (*Budd versus Davison*, the six-day court case involving the drains at Trentham House in 1880, and *Briscoe versus Briscoe*, his daughter's divorce). The change in their circumstances was certainly drastic. Margaret

 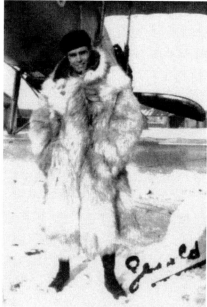

ABOVE, LEFT A postcard from 'Dunkerque', 1903, sent by Emily on a visit to her sister's house. (Bilton Archive)

ABOVE, RIGHT Gerald De Baecker, Letitia's son and Emily's nephew. This photo of Gerald was taken alongside his First World War bi-plane in the Balkans, where he was decorated with the Croix de Guerre. (Bilton Archive)

⁓ THE DE BAECKER FAMILY TREE ⁓

Frederick Charles De Baecker
Born: 1862 in France
Occupation in 1895: Ship Broker

Letitia Charlotte Davison
Born: 15 February 1868 in Bar
Moor, Ryton, Durham
Married: 30 December 1895 at
the register office in Kensington,
London
Residence in 1895: 92 Abingdon
Road, Kensington, London
Died: 1943 in Paris, France

Marie de Baecker

Henry Stuart
Married: 5 June
1925 at the
British Embassy
Chapel in Paris,
France

Gerald de Baecker
Born: 11
November 1895
in Dunkirk,
France
Died: 30 July
1944

Berthe Briant
Born: 5 June
1894
Married: 1919

Josse Frederick de Baecker
Born: 23 March
1913

Pierre De Baecker
Born: 22 May 1928 in St Malo, France

Davison's second family's lifestyle and aspirations were dashed, while their older siblings (apart from William Seton, who was still a bachelor living and working in Sheffield), had their own families and households to care for and could not offer much in the way of financial aid. There are no records to tell us when Alfred left for Canada, nor when Margaret actually returned to Northumberland and settled in Longhorsley. Their finances needed to greatly improve to fund their ventures, and it is possible that the Lavally estates were not sold until at least two years after Charles' death, sometime in 1895. That date seems to have been a much better year for them: Letitia was married in December 1895, to a dashing Frenchman named Frederick Charles De Baecker, a ship's broker. She went to live in St Malo, where Emily would spend Christmas and the New Year.

Nonetheless, the family struggled on (though with debts doubtless accrued as part of Margaret's new business in Longhorsley), and Emily went on to attain a degree. There is a story about Emily's graduation that has now entered local folklore. It appears in John Sleight's *One Way Ticket to Epsom*, and tells of an unusual celebration: Emily, it says, went onto the village green at Longhorsley with a glass jar of sweets from her mother's shop and threw them up in the air, one by one, for the village children to catch. What is not so certain is the year this event happened: some sources say 1895, and some 1908. Emily was enrolled at

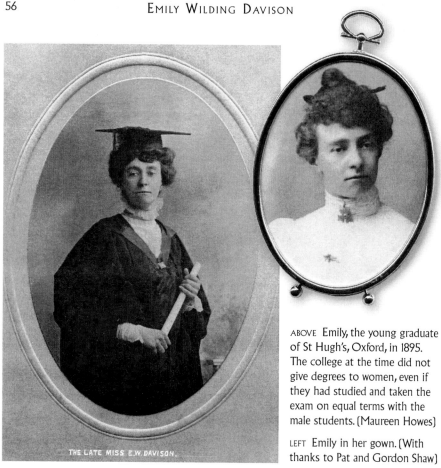

THE LATE MISS E.W. DAVISON.

ABOVE Emily, the young graduate of St Hugh's, Oxford, in 1895. The college at the time did not give degrees to women, even if they had studied and taken the exam on equal terms with the male students. (Maureen Howes)

LEFT Emily in her gown. (With thanks to Pat and Gordon Shaw)

St Hugh's from April to June of 1895, obviously to take the exam. She obtained a First Class (Honours) award in English Language and Literature from St Hugh's College, Oxford, in 1895, but was not given the award because at that time Oxford did not award degrees to women. This explains why the famous picture of Emily in her cap and gown, degree scroll in her hands, used by the WSPU on the St George's memorial service-sheet, is of an older Emily.

Many have debated whether Emily had one or two degrees. There is so much misinformation out there and it is difficult to be certain. She was certainly enrolled at St Hugh's from April to June of 1895, obviously to take the exam. Her actual degree was earned later, when she enrolled in September 1902 as an external student at the University of London. There she passed the intermediate examination in the arts, in 1906, followed by a First Class Honours BA in Modern Languages (English and French) in 1908.

First Year as a Governess

BETWEEN EMILY'S TWO DEGREES, she served for a short time as the 'live in' governess for the Moorhouse household at The Grange, Spratton. During this year the census records her mother Margaret Davison, widow of Charles Edward Davison, in Longhorsley village.

The mistress of the household was a New Zealander. Eight years earlier, on 19 September 1893, the women of New Zealand had won their citizenship, and the right to vote, after twenty years of campaigning. Women voted for the first time in the elections of 28 November 1893. It would not have been lost on Emily that this had been the year that her father died, in which Emily's hopes and aspirations suffered a drastic change.

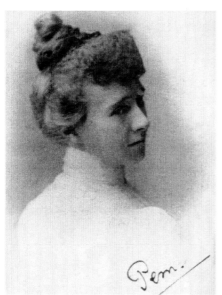 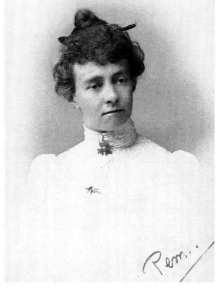

Pat Shaw, a Caisley / Wilkinson descendant, owns this previously unpublished photo (right) of Emily, taken by a Kensington photographer. Here we see her as a confident young lady — it is obviously the well-known 'over the shoulder' pose. Pem was Emily's childhood name, one she and her family used. She signed herself as 'Pem' to only her closest family and confidants. (Photo right courtesy of Pat and Gordon Shaw; photo left courtesy of the late Renee Bevan Archive)

Discussing how Emily's change in fortunes would have altered her outlook on life, Irene Cockroft has made some astute observations. 'Emily,' she once told me, 'on the threshold of life, was plunged into a different social class, "reliant on her own exertions"'. Contact with old school friends and teachers would have then taken on an added poignancy, though her former headmistress Miss Hitchcock has been quoted as saying (in Colmore's *Life of Emily Davison*, for example), 'I never heard her complain or express anxiety about her own future or that of her mother.' Having no 'expectations', and no dowry, was likely to destroy any chance of a marriage of equals for Emily. Education, therefore, might become vital in confirming a sense of one's self-worth. As Irene puts it, 'The esteem of comrades in the suffrage campaign, built upon courageous confrontation with authority, would also become important.'

Some members of the present-day Caisley descendants feel that Emily's path in some ways wasted her extraordinary education, one which few women at the time had access to. Others, however, feel that it was precisely *because* she was educated to such a high degree that she was able to fight for working-class wives and mothers who did not have a voice.

The 1891 census shows William at Hillgate Yard, Morpeth, by then head of the family colliery business. He lived there with his wife Elizabeth Isabella Caisley (*née* Blackhall). The couple had two children named John and Emily, and lived with his widowed mother, his sister, Dorothy, and her daughter, Jessie May. A Wilkinson nephew was also at the house. The family later moved to King's Head Yard in Bridge Street.

Census:
William Caisley, head of household, aged thirty-six, colliery owner and employer – born Morpeth

Elizabeth Caisley, wife, aged twenty-four – born Hepscott

John A. Caisley, son, aged four – born Morpeth

Emily Caisley, daughter, aged one month – born Morpeth

Elizabeth Caisley, mother, widow, aged seventy-two, living on own means – born Curlesheugh

Dorothy Caisley, sister, single, aged forty-seven, servant Dom – born Morpeth

Jessie M., niece, aged sixteen, dressmaker – born Bushy Gap

William T. Wilkinson, nephew, aged eleven?, assistant – born Bushy Gap

The Layland-Barrat Years, 1904–1907

EMILY ON HER TRAVELS

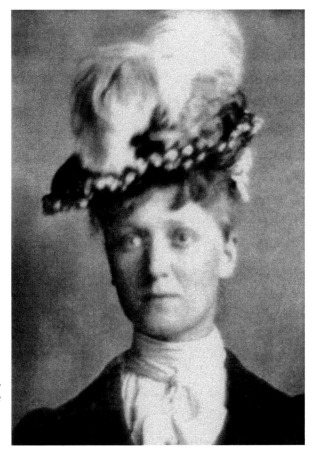

Jessie May Bilton, known
as Mamie, Emily's cousin.
Her descendant, Rod Bilton,
made his collection available
for this book, for which
I am indescribably grateful.
(Bilton Archive)

Dorothea.
1906.

After finishing her degree, Emily Wilding Davison took a position as a governess in the household of Sir Francis Layland-Barratt MP. This photograph, loaned by the late Mrs Renee Bevan of Hepscott, shows Dorothea Layland-Barratt, one of Emily's charges. By 1906 Dorothea would have been twenty, so she would no longer need a governess. This photograph may therefore have been her leaving present to Emily. For years this picture had pride of place in Renee's mother's house. Renee's mother was a first cousin of Emily, and was also named Emily. She was the daughter of John and Emma Wilkinson (*née* Caisley) of Edward Street, Morpeth. Emily Wilkinson married John Philipson Bell.

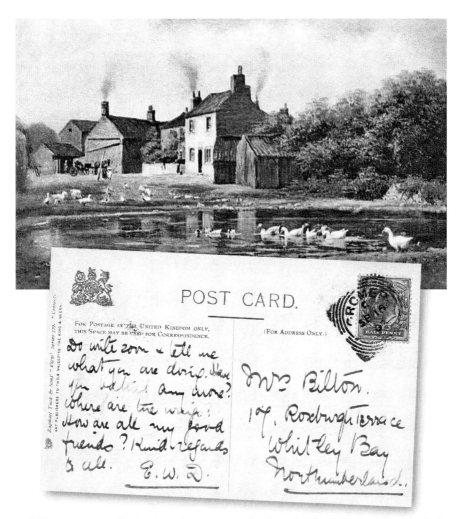

A 1903 postcard from Emily, obviously missing her family in the North. 'Do write soon and tell me what you are doing,' she writes. 'Have you [?] anyone? Where are the Wilks. How are all my good friends? Kind regards to all. EWD.'

The word which looks like 'Wilks' may be a pet name for the eleven Wilkinson cousins at Edward Street, Morpeth. Alternatively, the Women's Library (Ref GB 0106 9/26 of The Taylor Collection) refers to a Mrs Mary Ellen Taylor and her husband, Captain Thomas Smithies-Taylor, as the sister and brother-in-law of a Mark and Dr Elizabeth Wilks. Could they be the 'Wilks' Emily is referring to? All of the above were leading active suffragists and close friends of the Pethwidk Lawrences (who were bankrolling the WSPU). Dr Elizabeth Wilks was a member of the Women's Tax-Resistance League and her husband, Mark Wilks, was a teacher employed by the London County Council, a member of the Men's League for Women's Suffrage. Both were imprisoned for their beliefs. The year 1903 was the year that the WSPU was formed, but Emily was not yet a member. Lady Mona Taylor (mentioned again later) of Chipchase Castle was a leading North-Eastern Suffragette. Was Jessie already involved with the Newcastle Suffragists by 1903? Is there a family link no one has as yet discovered between Lady Mona Taylor's in-laws and Captain Thomas Smithies-Taylor? (Bilton Archive)

POST CARD.

FOR POSTAGE, IN THE UNITED KINGDOM ONLY,
THIS SPACE MAY BE USED FOR CORRESPONDENCE.

(FOR ADDRESS ONLY.)

Feb. 4. 1904 The Manor Home
 Torquay.

Ym sent a letter but
no address, goose!!
Do send me some
View Post. Cards.
 EWD.

Mrs Bilton
19 Roxburgh Terrace
 Whitley Bay
Northumberland

'You sent a letter but no address, goose!! Do send some view postcards. EWD.' This was a card to her first cousin Jessie May Bilton (*née* Caisley), the daughter of Emily's aunt, Dorothy Caisley. Aunt Dorothy was the keeper of the Caisley family's colliery mining accounts, mentioned earlier in this book.

The Women's Social and Political Union was formed by Emmeline Pankhurst with 'DEEDS NOT WORDS' as their motto. Their organisation was so named because they intended to carry out both social and political work to counter the apathy towards suffrage spreading through the Independent Labour Party. Isabella Ford of Leeds reported that there was not only a degree of indifference but even outright hostility from certain members of the Labour Executive, who were opposed to votes for women as they thought it would assist the Conservative Party. (See Sylvia Pankhurst, *The Suffrage Movement*.) (Bilton Archive)

BELOW This postcard was sent from Cromer, where the Layland-Barratts had a manor house, in March 1904. On the back, Emily wrote 'Here is a favourite view! Do send me some of <u>Newcastle</u> if you go there. EWD.' (Bilton Archive)

The Cromer golf links. Emily's friend and colleague Lilias Mitchell would later lead a publicity stunt on another golf course, switching all the flags for replicas in the suffrage colours. (Bilton Archive)

Mamie was unwell when this postcard was sent from Cromer: 'Hope you have recovered from the toothache,' Emily wrote on it. 'Certainly your letter did not sound v. cheerful. I had my last Bathe on Friday Oct 7th Machines are up now. EWD.' Bathing machines protected an Edwardian lady's modesty by allowing them to enter the sea via a stepladder from the front door (after they had undressed in privacy). (Bilton Archive)

Life at the manor house, Torquay. On the back of this postcard, Emily shares a joke with her cousin Mamie about the two 'Tynemouth's' (one near her cousin at Whitley Bay and the one in Devon, near Torquay – Teignmouth. 'Jan 21 1905. I am now at the Manor House, Torquay. I send you the view of the other Teignmouth. How are you all? EWD.' (Bilton Archive)

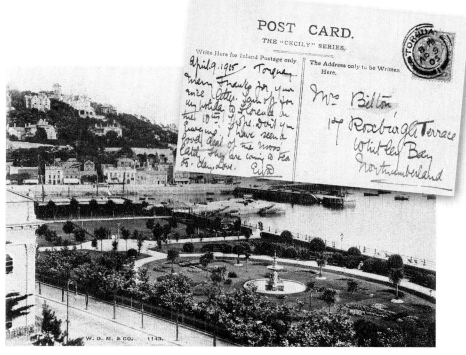

Continental travel begins: on this postcard, sent on 9 April 1905 from Torquay, Emily writes, 'Many thanks for your letter. I am off for my holiday to Florence on the 10th, I hope. Don't you imagine? I have seen a good deal of the Mosses lately. They are coming to tea today. Love EWD.' The mysterious Mosses regularly occur in Emily's and Mamie's correspondence from this era – perhaps they were friends in the town? (Bilton Archive)

France. At the start of their continental tour, it is possible that Emily stopped off to visit her sister Letitia in Paris for the first evening — and then could not resist sending her cousins images of the statue of Joan of Arc, the Women's Social and Political Union's patron saint. This would have been at least nineteen months before Emily herself joined the WSPU. She encouraged young women to learn of St Joan. The descendants of a suffragette wrote to me from Canada to tell me about their grandmother, Isabella Thompson Atkinson, the daughter of William Penley Atkinson and Sarah Elizabeth Young. Isabella was born in 1875 in Manchester Lane, Morpeth, and knew Emily and her Morpeth cousins. She died in Ontario, Canada, in 1951. Her descendants have two treasured possessions of their suffragette grandmother: her suffrage sash and a signed book given to her by Emily Wilding

PARIS. — Statue de Jeanne d'Arc, par Chartrousse
Collections ND Phot

Davison about the life of Joan of Arc. Isabella attended the Morpeth funeral procession, marching within a contingent of suffragettes from County Durham (where she had gone to live after she married). Her granddaughter is Dr Dorothy Pollock of Canada. (Bilton Archive)

Italy: Emily sent a number of postcards of 'Firenze' back to her family, of which this is one. The late Mrs Renee Bevan would often sit with me and discuss Emily's life with the Layland-Barratts. Emily would send her cousins postcards from her trips abroad with the family; when she was home, she would tell them all stories of the young girls. She was quite proud of being their governess. (Bilton Archive)

The Red House, Cromer, where Emily was governess, in 1905. Note the cross over the dormer window — that marks the room where Emily slept. Emily, as the governess, slept up in the servants' quarters. 'The cross shows my bedroom here. I expect you are back now. Do look for my cap. The bathing here is now done. I got one last on Thursday. Are you glad to be back now??? EWD.' (Bilton Archive)

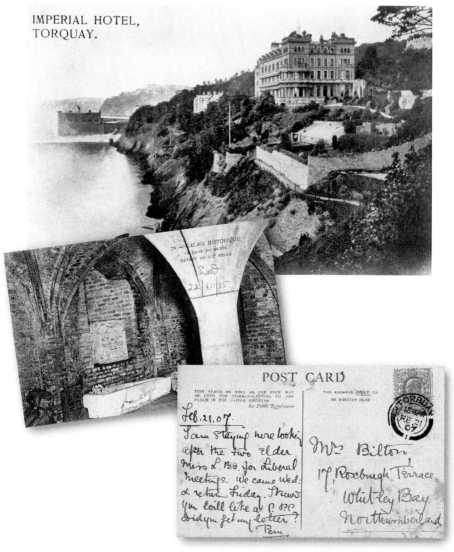

A card sent on 22 December, Christmas of 1905, from Calais. Emily was staying with her sister Madame De Baecker. For some reason there is a year's gap in the correspondence between Emily and her family from December 1905 until the beginning of 1907, when postcards from the households of the Layland-Barratts take up Emily's story again. Emily is recorded as joining the WSPU in November 1906, three months before she sent this postcard. Here she is still a governess in the household of the Layland-Barratts, and taking an active part in the social life of her charges. She then began to function as a chaperone, accompanying them to the Liberal meetings: their father, Sir Francis Layland-Barratt, was elected as a Liberal MP for Torquay in the 1907 elections. Emily obviously helped with the care of the family at this time, as a postcard sent in 1907 says, 'I am staying here [Imperial Hotel, Torquay] looking after the two elder Miss L.B.s for Liberal Meetings. We came Wed: & return Friday. I trust you will like a P.P.C. Did you get my letter? Pem.' In 1906, the Liberal Government came to power, bringing legal and social reforms. However, it did not fully support women's suffrage. (Bilton Archive)

9 April 1907, Primrose Day. In my view this is one of the most intriguing postcards in the Bilton Archive. The primrose was Disraeli's favourite flower, and Queen Victoria had a posy of primroses placed on his grave every 9 April. In its day, the Tory party was the working man's political party, establishing its 'Habitations' (as its meeting halls were called) in every town throughout the country. Researching for clues in the Northumberland Archives, I went through the treasurer's membership subscription stubs and discovered that Emily's nephew John Seton Davison was a member, as were his mother's Cranston relatives. To be honest, on reading through the local Morpeth and Newcastle-upon-Tyne newspapers, you get the feeling that they organised the best social occasions! The young members must have enjoyed the facilities as a meeting place. 'Have just been to see this statue. How are you? How does Gladys get on? Do write and say. I left on Wednesday,' Emily writes.

Who was Gladys? I asked the fount of all Morpeth knowledge, eighty-four-year-old Renee Bevan of Hepscott. She laughed, and said 'that was my Aunty Gladys'. Renee's grandparents were Emily's Uncle John and Aunt Emma Wilkinson (née Caisley). They lived in Edward Street, Morpeth, and had eleven children, seven boys and four girls. Gladys was born in 1891, and in 1907 she would have been just sixteen years old. Renee went on to say that the Wilkinson girls, in turn, were companion housekeepers and general assistants in their Aunty Meggie's corner shop at Longhorsley. Emily and Mamie must have been concerned about how Gladys was settling down to life with Aunt Meggie in the quiet, rural village 6 miles north of Morpeth after living in the market town surrounded by her brothers and sisters. Renee then told me that, as a young girl, when they went for a Sunday jaunt out in the car with Aunty Gladys, she would point out the place where Aunt Meggie lived. 'That window up there,' she would say, 'was my bedroom window'.

In the 1911 census return you will find Margaret Davison in Longhorsley, along with another of her nieces as her companion and housekeeper-cum-shop assistant. This time it was Renee's mother, who was also named Emily. Sisters Dollis and Elizabeth would later help with the baking and with making the confectionary — the Caisley women were all warm-hearted, hard-working and experienced cooks and confectioners. Their father had a dual occupation as colliery owner and publican: when his daughter Margaret was born in 1849, he held the tenancy of the White Swan in Newgate Street in Morpeth, just around the corner from the Caisley household in Bridge Street (next to Brumell's the solicitors, which is still there today). The Caisley home is now a branch of Specsavers. (Bilton Archive)

Lord Lexden, author of A Gift From the Churchills: The Primrose League, 1883–2004, highlighted its achievements at a dinner held by the Younger Members' Committee of the Carlton Club on 4 August, 2011. 'The League transformed the entire character of the Conservative Party', he said. 'With a working-class majority among its membership, it invented modern popular politics in Britain'. (http://www.alistairlexden.org.uk)

A postcard from a 1907 visit to Edinburgh. Emily was with a group of ladies who enjoyed gathering together to have musical soirees to entertain the rest of the family. Many of the suffragettes were known by pet names: John Sleight's book explains that one of the ladies in their group was known as 'Daddy' or 'Dad'. 'Having a grand time,' writes Emily on this postcard. 'Dad leaves tomorrow. EWD.' I have tried to solve the mystery of who this 'Dad' might be, but have found no conclusive proof. There was, however, a family named Dade, potato merchants in Newcastle, who married into a branch of the Davison family. Whether this is the source of the nickname we may never know, though the Dad here mentioned in this postcard is obviously a friend from Emily's musical circles.

September 1907 was spent in Edinburgh. The following October, Christabel Pankhurst wrote in *Votes* magazine that the WSPU were planning an active campaign in Scotland. Was Emily in Edinburgh in 1907, doing some liaison work for the WSPU? We are aware that Emily left the employment of the Layland-Barratts at the end of 1905, when Edward Seton, the second child of William Edward Seton Davison and Sarah, was born. This fits into the timeframe for when she joined the WSPU; this was after she met WSPU members in and around Salford, Manchester. (Bilton Archive)

The Bilton Family and Emily Wilding Davison on the beach at Whitley Bay. Seated on deck chairs, we can see Emily Wilding Davison (on the left), with Mamie on the right. Lewis junior is the man in uniform. (Bilton Archive)

Militant Suffragette, 1906—1913

IN AROUND 1893, Margaret Davison had returned to Northumberland. There, as mentioned earlier, she set up a bakery in Longhorsley, in order to support herself. Emily began teaching, and raised enough money to return to her studies, achieving (as again mentioned) a First Class Honours Degree in Language and Literature at London University. She continued to work as a teacher and governess.

As she grew, Emily became increasingly aware of the urgent need to fight for issues that affected the lives of women. She came to believe that a vote for women was the only way forward. She joined the Women's Social and Political Union in 1906, although she continued working as a governess. It was this very year that the term 'suffragette' was first used by the national press. It is possible that Emily was given leave from her duties as a governess to attend a family christening with her mother in Salford, Manchester, at this time. William Seton Davison's son Edward Seton Davison was born there in 1906 – Emily was probably there to give support and care for their toddler. That could have given Emily the opportunity to attend the local suffrage meetings in the area and commit herself to the suffrage cause. While she was in Manchester, the Pankhursts were extremely active.

In the summer of 2011 I attended the summer luncheon of the Morpeth Soroptimists on Lord Ridley's estate at Blagdon. To my astonishment, one of the speakers was a lady in her nineties named Florence Kirkby. She said how pleased she was to be asked to speak to the Morpeth ladies as she was very aware of the town's links to Emily Wilding Davison. It turned out that Emily had known her father. He worked as a suffragist alongside the Pankhurst family and with Emily Wilding Davison in Manchester. He always emphasized that all the suffragettes

Xmas.
The wish is old but still it shows
A friendship that endures:
This Christmas time, from dawn to close,
May happiness be yours.

Christmas card from Emily to her cousin Mamie, sent the year that Emily joined the WSPU. (Bilton Archive)

117

I, EMILY WILDING DAVISON of Longhorsley S O
Northumberland hereby bequeath all my personal property and money to my mother
Margaret Davison of Longhorsley S O Northumberland and I appoint the said Margaret
Davison EXECUTRIX of this my will Dated this 20th day of October 1909 -
EMILY WILDING DAVISON - Signed by the said Emily Wilding Davison as and for her
last will in our joint presence and by us in her presence - Witnessed by (1)
HELEN GORDON LIDDLE Peaslake Surrey (2) JANE RATCLIFFE 19 Parkfield St
Rusholme Mchr

ON the 30th day of August 1913 Probate of this will was granted to
Margaret Davison the sole executrix

End of letter "D"

ABOVE & RIGHT The last
will and testament of
Emily Wilding Davison,
made in Manchester the
night before she expected
to be sent to prison. In
2003, Moira Hughes of
Mooroolbark visited Morpeth
for the tribute to her
great-aunt Emily (she is the
granddaughter of William
Seton Davison and his wife
Sarah). Emily would stay with
her grandparents when she
came out of prison to recover
from her hunger strikes.
Helen Gordon Liddle, often
arrested with Emily, is noted
as a witness to Emily's will.
This document was made
when she was staying at
the home of Jane Radcliffe,
treasurer to the Manchester
WSPU, at 19 Parkfield Street.
(Maureen Howes)

DEATH ON OR AFTER 1st JANUARY, 1898.

Will.

BE IT KNOWN that *Emily Wilding Davison*
of the Cottage Hospital known in the county
of Surrey spinster formerly of Longhorsley
morpeth in the county of Northumberland
died on the *9th* day of *June* 19 *13*
at *the Cottage Hospital aforesaid*

AND BE IT FURTHER KNOWN that at the date hereunder written
the last Will and Testament

of the said deceased was proved and registered in the Principal Probate
Registry of His Majesty's High Court of Justice, and the administration
of all the estate which by law devolves to and vests in the personal
representative of the said deceased was granted by the aforesaid Court
to *margaret davison of longhorsley*
aforesaid widow mother of deceased
the sole executrix

named in the said *Will*

Dated the *30th* day of *august* 19 *13*.

Gross value of Estate £ *186*. *1*. *7*
Net value of Personal Estate £

(74,188). Wt.44,345—251. 12,000. 3/12. A.&E.W.

A letter to the *Manchester Guardian* on militancy and the suffrage issue. 'Women have resorted to violence,' the letter writer shares, 'because they despair of waking in [the 'unprincipled' politicians] any response to arguments or reasoned appeal ... Nothing could bring failure save the surrender of the militants, and they will never surrender.' (Maureen Howes)

CORRESPONDENCE.

THE POLICY OF THE MILITANTS.

To the Editor of the Manchester Guardian.

Sir,—You assert that violence is a policy of despair. In one sense you are right, and we of the W.S.P.U. fully admit it. Women have resorted to violence because they despair of waking in the unprincipled politicians who at present control the nation's affairs any response to arguments and to reasoned appeal. As every student of history knows, and as every great statesman has told us, Governments yield to fear and not to persuasion, and the present Government is, to say the least of it, no exception to that rule.

As I showed in my previous letter, every advance which the cause of votes for women has made since the Liberal party took office can be traced to militancy and the Government's desire to avert it. For public meetings and every other form of constitutional agitation the Prime Minister has shown an utter contempt. Belittle as you will the patient agitation of the past forty years, you cannot deny that since the beginning of the "New World" for women (which you seem to think synchronises with the beginning of militancy) there has been a "constitutional" agitation which for vigour and magnitude is unequalled by any other agitation of the present day. The Prime Minister does not even admit that any such agitation exists. We see no possibility of increasing the effect of "constitutional" agitation. Bigger meetings are impossible, because the bigger halls have already proved too small to hold suffrage audiences. We repeat that expansion on the constitutional side is not possible, and if it were possible how could it prove effective? It is, in fact, only in the direction of militancy that any real advance can be made.

Of the triumph of militancy we do not for one moment despair, for what militancy has achieved before it will achieve again. Nothing could bring failure save the surrender of the militants, and they will never surrender. The Government have no power to break the spirit of the militant women, nor has the nation, if you choose so to describe the enfranchised portion of it which has so serenely neglected to share its political power with women. It is too late now to chide us for what you describe as an attempt "to impose on Parliament and on the nation a political reform by outrage and terror." You and Parliament and the nation should have given votes to women before the present situation arose.—Yours, &c.,

ANNIE KENNEY.

4, Clement's Inn, Strand, London, W.C.

August 20.

were charming, intelligent, feminine ladies, and that they made a point of being well-groomed and articulate. I was able to arrange to visit Florence in her home the following week, and she said that her father was adamant that history had got it wrong about Emily.

Joining the WSPU was simple. As Emmeline Pankhurst said, 'Any woman could become a member by paying a shilling, but at the same time she was required to sign a declaration of loyal adherence to our policy and pledge not to work for any political party until the women's vote was won.'

Then, in 1908, Emily became one of the WSPU's chief stewards at a demonstration in London. On 21 June, eighteen months into her membership, Emily was steward for the Marylebone Station section of the Albert Hall meeting. The WSPU organised a demonstration of over 7,000 women in Hyde Park. Yet that number of marching women pales into insignificance compared to the 1908 Suffragette Pageant, London. There, 66,000 marching women dressed as historical figures, in a file 4 miles long, marched through London. That must have been one of the most impressive shows of solidarity that the capital has seen, all organised by the WSPU. In the family papers of the Bilton family we find evidence of that event in the form of a photograph of one of the women in their costume. Some detective work was carried out by myself, my friend Anne Findlay from Hepscott and V. Irene Cockroft, the great-niece of Ernestine Mills (the enamellist), who was on a three-day visit to Northumberland. Together we identified one of the photographs in the Bilton Archive as Lilla McCarthy, vice-president of the Actresses' Franchise

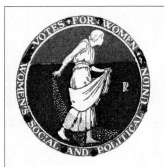

TO
GREET YOU

VOTES FOR WOMEN · WOMEN'S SOCIAL AND POLITICAL UNION

"What men call luck
Is the prerogative of valiant souls,
The fealty life pays its rightful kings."

James Russell Lowell.

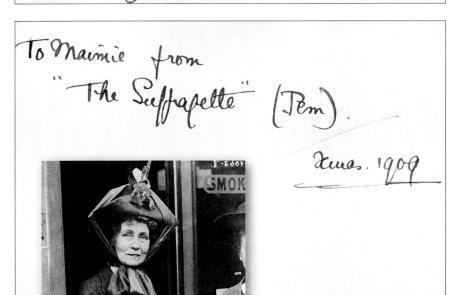

To Maimie from
" The Suffragette " (Pem).

Xmas. 1909

ABOVE A postcard sent by Emily three years after she joined the WSPU. She signs it Emily 'the suffragette'. (Bilton Archive)

LEFT Mrs Pankhurst in 1913, the year of Emily's death. She was arrested as she left to attend Emily's funeral. (George Grantham Bain Collection at the Library of Congress, LC-DIG-ggbain-05100)

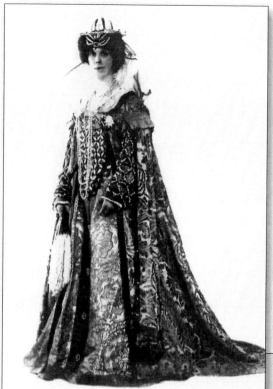

Lilla in her pageant costume, dressed here as Elizabeth I. The 66,000-strong Suffragette Pageant was organised by the WSPU, with a file of marching suffragettes in costume 4 miles long, as their response to the jibe that they did not have a great following. (Bilton Archive)

Lilla, 'Xmas 1924'. For the above signed picture to be sent to Jessie May in 1924 is intriguing: Lilla (or Lillah) was a woman with friends in high places, both socially and theatrically. Her biography was illustrated by Edward Dulac, and she later became Lady Keeble OBE. Emily's appreciation of the arts and theatre is reflected by the bond of loyalty shown by suffragist friends such as Rebecca West and Arncliffe Sennett (who spoke on the evening of Emily's funeral from the steps of Morpeth's Town Hall). (Bilton Archive)

League (a group of people connected to the theatre dedicated to working for women's suffrage, specifically by staging plays about the topic), and friend and leading lady of George Bernard Shaw (she played Ann Whitfield in *Man and Superman*, and was to appear in a suffrage-themed play called *What Every Woman Knows* in the year of the march). She was also a close friend of Prime Minister Asquith (who nonetheless held on to his anti-suffrage views), and later became Lady Keeble. There was also another photo of Lilla in a simple shift dress, dated 1924 and signed 'Lilla, Xmas 1924'. So what should we make of that: did 'Lilla' also know Jessie May Bilton?

Emily became more involved in militant activity and, in 1909, was arrested on a number of occasions in Manchester, London and Newcastle. On 1 March 1909, Emily Wilding Davison was one of the twenty-one women arrested at Caxton Hall while attempting to serve Mr Asquith with a petition. She was arrested, and given one month's sentence. A few months later, on 11 June 1909, she wrote in *Votes for Women*: 'through my humble work in this noblest of all causes, I have come into a fullness of joy and an interest in living which I never experienced.'

Then, in July, Emily interrupted a meeting at Lime House addressed by David Lloyd George (then Chancellor of the Exchequer) and was arrested, along with Mary Leigh, Alice Paul and Lucy Burns. She received a two-month sentence and underwent a hunger strike, broken by force-feeding. She was released after five days. Fellow prisoner Mary Leigh was possibly one of her closest friends. After Emily's death, Mary visited her grave every year on the anniversary of the Epsom Derby until she grew too old to continue making the journey. Caisley family members speak of seeing her with their parents: she would arrange beforehand to have a posy of forget-me-nots made by Matheson the florist. The Women's Library have receipts from Bart Endean, the local monumental stonemason, who had a yard and premises in St Mary's Field, near the Sun Inn. Mary arranged, by subscription with other suffragettes, to have the stone on Emily's grave cleaned and the writing blacked in again on the fiftieth anniversary, in 1963.

In September she was twice arrested, the second time for throwing stones at the windows of the Liberal Club in Manchester. She again went on hunger strike, and when threatened with force-feeding barricaded herself in her cell. In an attempt to force her out, the prison warders pushed a hosepipe through her window and flooded the cell with cold water. As the cell began to fill with water, Emily refused to open the door: the guards were forced to break the door down to prevent her from drowning. Keir Hardie (the Labour Party leader) took the case to the House of Commons and complained about the treatment Emily Davison had received at Strangeways. The general public appeared to agree with him, and Emily decided to take legal action against the men responsible for the hosepipe incident. On 19 January 1910 she was awarded damages of 40s when Judge Parry announced in her favour.

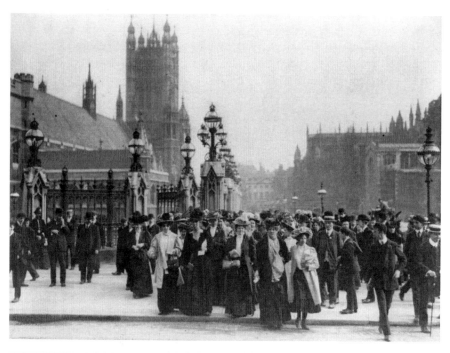

A group of suffragettes outside Parliament in 1910. In this year, after complaints in the House of Commons, Emily was awarded 40s damages after suffering a near-death experience in Strangeways Prison. The next year she broke into this building to hide – much to her family's amusement when they heard about it. (George Grantham Bain Collection at the Library of Congress, LC-USZ62-45062)

Keir Hardie, who stood up in the House of Commons to complain about the way that Emily had been treated in prison. (George Grantham Bain Collection at the Library of Congress, LC-DIG-ggbain-01094)

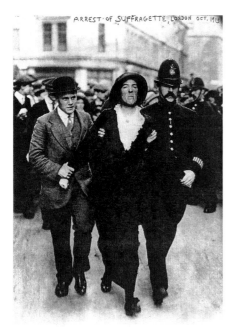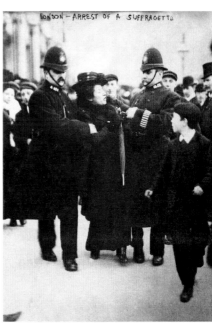

A familiar sight: the arrest of a suffragette. These women were arrested in October of 1913, just a few short months after Emily's death. (George Grantham Bain Collection at the Library of Congress, LC-USZ62-70384 and LC-DIG-ggbain-10397)

In October 1909 – only a few days after being released from Strangeways – Emily Davison was caught throwing stones at a car taking David Lloyd George and Walter Runciman of Doxford Hall to a meeting in Newcastle, along with Mary Leigh and Lady Constance Lytton. The stones were wrapped in paper on which the words 'Rebellion Against Tyrants is Obedience to God' were written. Again, the women were arrested – and again the force-feeding procedure was authorised, although Lady Lytton was not force-fed but instead released because of her already poor health. Lady Lytton had managed a direct hit with a stone: she later wrote, in *Prisons and Prisoners*, of her time in the Charlotte Square gaol in Newcastle. She was sentenced to four weeks' imprisonment, but after a fifty-six-hour hunger strike was released because of a heart condition. To expose this preferential treatment, Lady Lytton later got herself re-arrested, this time disguised as a working-class girl. She was sentenced under the name 'Jane Warton' in Liverpool, and endured truly horrific treatment that damaged her health for the rest of her life. On 20 October Emily was arrested again, this time with Helen Gordon Liddle.

In April 1910 she became a paid worker of the WSPU.

The scale and daring of Emily's militant acts increased. These included hiding herself in the ventilation shafts of the House of Commons. Moira Rogers of Bristol, granddaughter of Georgina Davison Bayly (Emily's half-sister), shared

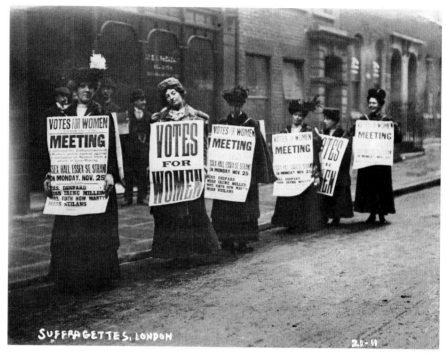

Suffragettes in London. (George Grantham Bain Collection at the Library of Congress, LC-DIG-ggbain-00111)

Doxford Hall, whose owner was once stoned by Emily Wilding Davison. Walter Runciman's wife Helen Stevenson was the granddaughter of James Anderson. James was the Presbyterian minister of St George's church, whose manse was in Newgate Street, Morpeth. Emily Wilding Davison would have been aware of the Morpeth Anderson connection, but as yet we have not proved a link to one of Emily's many Morpeth Anderson relatives. (Courtesy of Doxford Hall Hotel, Northumberland)

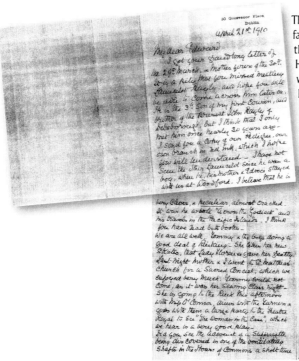

The letter from the Baylys, father and son, discussing the discovery of Emily in the Houses of Parliament. 'Fancy, we hear that it was Aunt Emily.' (Courtesy of the late Moira Rogers)

the following letter with me, written on 21 April 1911 by Edward Crosbie Bayly of 30 Grosvenor Place, Dublin, to his son, Edward Crofton Seton Bayly: 'Did you see the account of a suffragette being discovered in one of the ventilating shafts in the House of Commons a short time ago? She must have got in on Saturday and was found on Sunday evening, waiting for the morning's sitting, where she intended making a speech – and fancy, we hear that it was Aunt Emily! She was there for 28 hours.' Fittingly, *Saga Magazine* reported that on 6 March 2003 Tony Benn had illegally placed a plaque in the cupboard occupied by Emily.

This protest also served another function. In 1911, the National Census of the Population of Great Britain was chosen as a special vehicle to illustrate the protests regarding votes for women. Many women throughout the kingdom took part in a national protest to highlight women's suffrage issues. Emily, in a letter to the *Morpeth Herald*, stated that she was recorded at her lodgings in Coram Street, London – and also at the Houses of Parliament! She had been hidden inside on the night of the census, in the crypt of the House of Commons and then inside a broom cupboard. (I have not been able to trace the third census return, but the Coram Street residence and the Houses of Parliament return can be seen online at the census website.) This was part of a tactic that originated with Alice Clark and the Tax-Resistance League. Lawrence Houseman, who was a male suffragist, took particular glee in the organisation of resistance to the 1911 census, as census resistance suited the mentality of the non-heroic

RIGHT Inside the House of Commons, where Emily was officially resident on the night of the 1911 census. This chamber was destroyed by a bomb in the Second World War. (Crown Copyright)

BELOW The report of Emily's arrest. Moira Hughes of Australia told me that her grandparents, William Seton Davison and his wife Sarah, often cared for Emily after her prison sentences because William Seton Davison had had a medical background as a young man. It was not an easy time for the family: their children found it necessary to change their surnames at school in this period.

Suffragist and Letter-boxes.
At Bow-street Police Court yesterday Emily Wilding Davison, a teacher, was committed for trial on a charge of attempting to place in the post-office letter-box at Parliament-street Post Office a quantity of linen saturated with kerosine, and in a letter-box at the Fleet-street Post Office a box of wax matches wrapped in linen and paper and saturated with kerosine, to which she had set light. (p. 2)
Racing at Newbury.

many. Houseman had no idea how many women slept at his house that evening – he was barred from his own door and returned the following morning to find that his guests had departed and left 'by way of recompense a nicely prepared breakfast.' The census officials recorded his entry thus: a quantity of females, names and ages unknown. Josephine Butler, the suffragist and reformer, used her 1911 census return to state she was born on Flodden Field, Scotland, which is not exactly true – the battlefield was south of the border in Northumberland, near her birthplace of Milfield (where Emily's branch of the Davisons originated from before they settled in Alnwick).

In 1911 Emily and Charlotte Marsh were arrested for breaking windows on Regent Street. In November 1911, Emily was again arrested, this time for setting fire to letter boxes. This was an isolated but significant political crime carried out on her own initiative: she then immediately turned herself in to the police so that the postal workers, who were then on strike, would not be accused of the crime. In December she was given a six-month sentence, during which she twice resumed her hunger strike. By now convinced that women would not win

the vote until the suffragette movement had a martyr, Emily threw herself from a staircase in the prison, landing on wire netting some 30ft below. The netting prevented her from being killed, but Emily suffered severe injuries.

Suffragette Martyrs

Emily Wilding Davison was in fact the fourth suffragette to give her life for the cause.

Between December 1910 and December 1911, three other suffragettes died, one of whom was Mrs Emmeline Pankhurst's sister, Mary. They had died from injuries received while in prison, or while protesting. Their deaths, and their funerals, occurred without attracting any undue media notice – and sadly Emily was not the last suffragist to lose her life. Francis Sheehy-Skeffington (1878-1916), a respected Irish pacifist and suffragist, was murdered by the authorities – whilst handcuffed and captive – in the barracks at Dublin. The three women who died before Emily were Mary Clark, Henrietta H. Williams and Cecelia Wolseley-Haig. Mary Clark (*née* Pankhurst) died on 25 December 1910, after being released from Holloway two days earlier. Her death was caused by an embolism resulting from force-feeding in

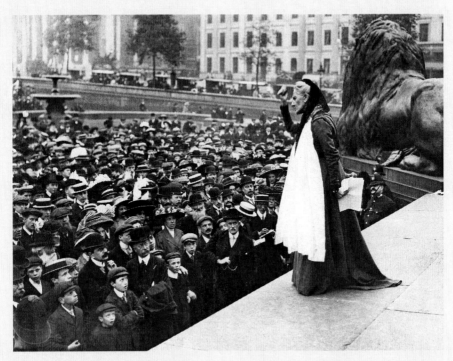

London, 1911, the year that Emily hid inside the House of Commons. Suffragette Henriette 'Helen' L. Williams also died this year, after being badly hurt during Black Friday. Emily was then arrested for smashing windows in Regent Street as part of the WSPU campaign to protest the treatment received by women on that day. This 1911 image shows a speech given by Charlotte Despard in Trafalgar Square. (THP)

SUFFRAGIST MEETING AT MORPETH.

A public meeting, under the auspices of the North-Eastern Federation of Women's Suffrage Societies, was held in the Town Hall, Morpeth, last Friday, when the suffrage case was ably stated to a large audience by Miss Gordon, organiser for the Federation, and Miss A. Maude Royden.

Miss Gordon, who presided in the unavoidable absence of Dr. Ethel Williams, discussed the chances of projected legislation this year. She denied that the movement was a new movement, and said it had been in existence for over fifty years. The demand for the vote was only part of the much greater movement, the demand for the emancipation of women.

During that time about thirty measures had been introduced in the House of Commons, having for their object the granting of the vote to women. On seven occasions had the measure been voted upon and obtained a substantial majority, but because it was a woman's measure it had been put upon the shelf. Last year only 88 members of the House of Commons voted against woman's suffrage. Their measure last year was known as the Conciliation Bill. It pleased the Liberals by preventing plural voting, and it pleased the Unionists by not admitting too many to the vote at one time.

The Government this year intended to introduce a measure of electoral reform and a deputation to Mr. Asquith and Mr. Lloyd George had been informed that if an amendment was moved to the Reform Bill, and carried in the House of Commons, giving votes to women, Mr. Asquith would support this amendment and treat it as part of the original Bill. Both Sir Edward Grey and Mr. Lloyd George had announced their willingness to move such an amendment. The amendment they hoped to have passed was one which would give votes to women householders and also to married women as joint occupiers with their husbands. That would enfranchise between seven and eight million women, as against eleven or twelve million men. They had several strings to their bow. First was the Conciliation Bill, then the amendment to Mr. Lloyd George's Reform Bill, and finally there was a possibility of women being included in the Irish Home Rule Bill.

Miss Royden, in the course of her address, said the most serious objection of most people was that votes for women was a new thing. All reforms, however, were once objected to because they were new. When Florence Nightingale proposed to go out and save our army in the Crimea, it was not considered ladylike to do such a thing. That Miss Nightingale, who was quite a young woman, should positively go out and nurse soldiers in the Crimea without any chaperon at all filled the British public with positive terror. (Laughter.) But she went, and they all knew the noble work she did, and with what enthusiasm she was received on her return.

Then some men said politics were such a dirty business they could not bear to see women mixed up with them. There was not a man in the House of Commons who did not owe some of the votes that sent him there to the canvassing of women. It was difficult to do political canvassing with perfect purity of mind and sincerity of purpose.' It was not difficult to go and register their vote. If women were allowed to do political canvassing, she thought it was too late for people to say politics was dirty work, for canvassing was far more dirty than voting. She hoped for her part to see a law passed making canvassing illegal altogether. (Applause.)

Speaking of woman's duty to the home, Miss Royden said it was a fact that the average woman, the normal woman, and she thought she might say the best woman, did find her interest cen ... l there. It was for that reason she was ... ng to-day for a vote. Tens of thousands of women were living in homes not fit for human beings. It really did not seem that men had legislated for them so perfectly that they were beyond the reach of advice. She did not think the State would be better ruled by women than by men. All they claimed was that women also were human beings, and that men, who had had all the power, had not always seen the interests of women quite as clearly as they had seen their own. Most women wanted to live in their own homes, and for that reason they were asking for power to make homes fit for women to live in. To whom did it matter most if Housing Acts were badly drawn up and badly administered? If a woman sat in a house all day, and that house was insanitary, she would be the first to suffer. She did not think there was a woman who could not give some hints to the man who built her house. That was a question on which, if they allowed women to assist in legislation they would get, not perhaps a more intelligent point of view, but a different point of view, and a force of feeling which they had entirely failed to arouse in men. When men and women were both voting they got the rights of both recognised.

Miss Royden proceeded to point out anomalies in the laws relating to the custody of children and the relations between husband and wife. Men, she proceeded, were a little suspicious about what women were going to do with the vote when they had it. She apprehended nothing revolutionary. In Australia and New Zealand and in several of the United States women had already the vote, and the beneficial effect on public life and legislation was widely acknowledged.

One or two questions were put and answered at the close.

prison. The other two suffragettes died from injuries sustained during a deputation to the Prime Minister in London on Black Friday, 18 November 1910: Scotswomen Henriette 'Helen' L. Williams, a native of Glasgow who later resided in Essex, and who died on 2 January 1911, and Cecelia Wolseley-Haig, of the Haig whisky family, who died on 31 December 1911.

Their deaths were not marked with public processions, nor were their funeral services dedicated to petitioning the King. Indeed, Frank Sheehy-Skeffington's body was only released on the condition he would be buried quietly without any public display. Today, their stories are not widely known, though commemorative trees were planted by Annie Kenney in their memory in the Blathwayte suffragette arboretum.

All four typified the determined character of the suffragist, the sheer courage that allowed them to withstand years of derisive lampooning, imprisonments and force-feeding. The media's general attitude towards suffrage campaigners was dismissive, but with a tongue-in-cheek sense of humour the suffragists often outwitted the media's attempts to ridicule them. For example, the term 'suffragette' comes from a scathing article in the *Daily Mail*. The women took it and used it as a badge of honour, proclaiming the term wherever and whenever they could. Similarly, in response to being dismissed as 'deranged cranks', Frank Sheehy-Skeffington wittily responded: 'a crank is a small engine that causes revolutions.' The militants, and their wide circle of friends, were in fact intelligent, confident women whose debating skills often trounced the arguments of the best political minds of the day. They were also resolute: once a decision was agreed upon they were totally dedicated to seeing it through.

Finally, they were brilliant publicity strategists, and would have understood and appreciated the power that lay behind the Pathé News lens. Once their protests were caught on camera their message went around the world. The news-reel camera was state-of-the-art equipment in its day, recording history as it was actually happening.

OPPOSITE The *Morpeth Herald* of 23 February 1912 reported on a 'suffragist meeting' in Morpeth. Dr Ethel Williams, who should have been the speaker that night, was unavoidably detained; she was the first female doctor in Newcastle. She was not normally militant, but in 1912 she refused to pay her taxes until she knew the fate of the Conciliation Bill. (See Elizabeth Crawford, *The Women's Suffrage Movement*.) (Mackay Archive)

The Epsom Story Begins

ON 4 JUNE 1913, the most important date in the racing calendar – Derby Day – Emily Wilding Davison ran onto the racecourse and tried to grab the bridle of King George V's horse, Anmer. The horse struck her, and the impact fractured her skull. Emily died on 8 June, without regaining consciousness.

However, the Epsom story really began eighteen months before Derby Day, when a group of Morpeth suffragettes met upon the common. Emily was there selected to carry out a protest at the upcoming Derby when she drew the shortest straw from a proffered bunch...

A MODERN GULLIVER.

Cartoon satirising the Aberdeen shore porters' view of the suffragettes; they treated these women very cruelly. One porter said in court that he 'thought he could handle ten of them'. (Maureen Howes)

In 1912, suffragettes from all over the United Kingdom gathered to disrupt the political meetings held at the local music hall in Aberdeen. Arrests swiftly followed.

Emily Wilding Davison was herself arrested, very forcefully, on the platform of Aberdeen's joint railway station. She was thrown to the ground in order to subdue her; the arresting officers then pinned her down by sitting on her. The arrest was the result of a dreadful mistake which saw Emily take a whip to a Lloyd George 'lookalike'. The poor man was, in fact, a local Presbyterian minister putting his wife on the train. The story is well known, of course. However, what is not widely known is the reason why she and hundreds of her fellow suffragettes were angrily barricading the station that day: the women had ringed the railway station hoping to confront the famous Lloyd George as he entered the station, in order to protest about the serious injuries that had been caused by the unreasonable manhandling by the Aberdeen shore porters – who were reportedly extremely derisive, aggressive and belligerent – of the suffragettes whilst they were supplementing the Prime Minister's security arrangements.

Emily's arrest therefore happened in an extremely heightened atmosphere; the platforms were patrolled by a throng of enraged suffragettes, and CID officers, police constables and even more shore porters (to add extra muscle) all mingled with the crowds. When the cry rang out from inside the station – 'There he is!' – Emily Wilding Davison was the first suffragette to get to the man everyone thought was Lloyd George. When charged, she gave her name as 'Mary Brown'. (Mary Brown was the maiden name of her friend Mary Leigh.) Upon her release she returned to Morpeth – and preparations for Derby Day began.

David Neville, the author of *To Make Their Mark*, kindly shared with me his Morpeth Suffrage Society notes. The Morpeth Suffrage Society was not a militant society, but David's notes show that membership was steadily increasing in the area during 1912 and 1913. By 28 February 1913 Morpeth membership was up to seventy: even the mayor had joined by the end of May. His notes also reveal that a few feathers were being ruffled locally by Emily, now a nationally known suffragette with many relations in the town. She had taken up residence in Morpeth with a housekeeper, and was encouraging the local women to consider a more militant approach.

Since Emily's most recent imprisonment in Aberdeen, life for her (and her mother) had become rather difficult, and relationships with the neighbours were becoming strained. The increased activity that Emily was stirring up in the area did not make matters easier, and by 1912 Margaret Davison was experiencing a few local problems. The 'small village' atmosphere was beginning to affect her business, and local gossips began to scurry into her shop to sneer at Emily's latest escapades whilst they shopped.

MINISTER LASHED WITH A WHIP.

Dec 1912

Mistaken for the Chancellor

SUFFRAGETTE ARRESTED.

An extraordinary incident, more sensational perhaps than the discovery of the Suffragists in the Music Hall last night, or the proceedings in the Police Court to-day, took place at the Joint Station this morning.

During the morning interested knots of spectators stood about the platform awaiting the departure of Mr Lloyd George, and Suffragists could be seen moving through the crowd.

To all appearances they were prepared for the contingency, and one young woman attracted more than usual attention by her bulging jacket.

Three minutes before the departure of the 10.10 Caledonian train to Stonehaven, the Rev. Forbes Jackson, Crown Terrace Baptist Church, Aberdeen—a gentleman not unlike the Chancellor, was observed to step from a carriage.

"That Cad, Lloyd George!"

The leader of the suffragists immediately raised the cry, "It's that cad, Lloyd George!" A rush followed, and Mr Jackson soon found himself surrounded by an excited mob, the central figure of which was the suffragist waving a large dog-whip."

Mr Jackson could be observed protesting against the action of the women, but the ringleader, stepping forward, lashed him across the face with the whip, exclaiming, "Don't disguise yourself. I charge you, Lloyd George."

While making the statement the Suffragist continued to swing her whip across the minister's face, inflicting ugly injuries.

The station officials were astounded at the turn of events, and Mr Lamont, Caledonian Railway, rushed forward and seized the thoroughly infuriated woman.

With marvellous agility the suffragist sprang aside, however, and lashed out once more as Mr Lamont advanced, ____ ____ ____ stroke with the whip across ____

Mr Jackson, despi____ ____ ____ ____ effort to pacify the s____ ____ ____ again lifted the whip____ ____ ____ tace with the roma____ ____ ____ Lloyd George, you c____

Porters now came ____ th. station, but bo____ ____ calmed she had to ____ form, where she w____ van arrived.

She will appear____ Monday.

MISTAKEN FOR MR LLOYD GEORGE.

SUFFRAGETTE'S ERROR.

MINISTER WHIPPING CASE AT JOINT STATION.

AMUSING EXPLANATION.

Public interest in the militants has not been allowed to wane in Aberdeen, and yesterday morning, when another sequel to Mr Lloyd George's visit was to be heard in the Police Court, the somewhat limited accommodation there was taxed to its utmost. Many fashionably attired ladies were anxious to gain admission. Some endeavoured to secure entrance by other means than the door for the public, but they had to take their chance with the rest of the waiters. The "gallery" was again largely composed of members of the fair sex. In the corner allotted to the witnesses was the Rev. Forbes Jackson, who suffered physically for being, in the eyes of the Suffragette, too like the Chancellor of the Exchequer. There was a larger crowd outside than inside. Behind the dock a couple of stalwart 'tecs found a seat. Bailie Robertson was on the bench.

"Mary Browne, alias Emily Wilding David, son," cried the bar officer, and accused entered with a smile.

The Clerk—Do you still adhere to your plea of not guilty?

Accused asked that the charge against her might again be read.

The clerk then read the charge—to the effect that—

On 30th November, within the Joint Station, in a compartment of a railway carriage forming part of a Caledonian train, accused assaulted the Rev. Forbes Jackson, minister of Crown Terrace Baptist Church, residing in Great Western Road, by striking him on the head and shoulders with a whip and seizing him by the collar of the coat and shaking and pulling him about, and conducted herself in a lawless and disorderly manner, and committed a breach of the peace.

MINISTER'S STORY.

The Rev. Forbes Jackson was the first witness, and told how about 10 o'clock on Saturday morning he was in the corridor of a carriage at the station.

The Fiscal—Did anybody attack you?
Witness—Yes, the lady.
The Fiscal—Just tell the magistrate what

____ a blow after that I came back. The police had taken her into a lobby. I went up to the office, and to my astonishment she handed me a very clever quick idea on the loft jaw with her clenched fist. That was the conclusion of the whole matter so far as I was concerned. It was her hand?—Yes, her left hand I think.

I suppose it was not a severe blow?—Well, it was a woman's blow. (Laughter.)

She didn't hurt you much (Laughter) were no marks on you?—Well, no.

How often did she strike you?—They came pretty rapidly, and I did not keep count naturally.

Naturally. Were there half a dozen?—I think so, and more.

Then in the corridor she struck you again with her fist?—Yes. She still went on. Though people in the carriage told her—You have made a mistake. This is a minister." She might have known that by my looks.

Cross-examined by Miss Browne—
You preached on Sunday in your church, morning and evening?—Yes.

It is a fact that you preached without notes on Sunday morning?—It is.

How did you preach without them on Sunday? It so happened that owing to a little inadvertence of the previous day, I had over-looked my notes, and so had to make a virtue of necessity.

Did you not know before that you were so like Mr Lloyd George?—(laughter)—I never knew until that morning—I do not know yet, as a matter of fact.

Were you not walking in the afternoon? rumour reached me that Mr Lloyd George had been seen in the afternoon?—I never heard that. Were you not walking in the afternoon?—I do my pastoral work in the afternoon—I was. Then, Mr Jackson, on Saturday were dressed as you are now? Except that I had a muffler on.

I take it that you were not dressed as a minister of the Gospel?—As I say, I had my muffler on. (Laughter.)

What kind of hat were you wearing?—My ordinary tall hat.

Apology Declined.

You were given to understand that I ____ ____ ____ you had been assaulted instead of Lloyd George?—Yes.

And you accept that apology?—No.

You are quite satisfied in your own mind that I had no personal bias against you?—I am quite satisfied that you had, and have still, a case of a very evil kind against the man you thought I was.

But there was nothing to prevent you accepting the apology? When the apology was offered to me by a lady friend of yours, I asked her if you were sorry for your mistake.

Accused—Very interesting.

Mr Jackson (continuing)—When I asked her if you were sorry for the mistake she replied—"Yes," and when I further asked her if she regretted her conduct, she replied that she emphatically was not. Therefore I refused the apology.

Do you think, as a minister of the Gospel, as a Christian, that you did right in refusing that apology?—Had the injury been intended for me, and the apology then presented, I would gladly have accepted it, but so, in my opinion, the apology was in the nature of "cover" for

to Mr Lloyd George?—No. I never heard that before.

Mr Lamond, Caledonian passenger agent, described how on Saturday morning his attention was called to a disturbance in a carriage. A few people had collected, and there was great excitement amongst the passengers. He could not understand the cause until Mr Jackson told him that he had been taken for Mr Lloyd George by the accused, who was being restrained by one or two other passengers. They were trying to keep her away from Mr Jackson.

She seemed to be trying to get at him again?—Yes, she made repeated efforts.

In Disguise.

Witness said that when she made no sign of obeying his requests to leave the compartment, he had to forcibly remove her. She gave no explanation, but he heard her say that he (Mr Jackson) was Mr Lloyd George disguising himself.

The traffic inspector of the Caledonian Railway Company was the next to enter the witness-box, and his evidence corroborated that of Mr Lamond. He stated that Miss Browne struggled repeatedly while Mr Lamont and he were holding her to get at Mr Jackson.

In cross-examination, Miss Browne questioned witness as to official position in the case. Had she known that by her looks, and especially on the allegation that he saw her strike Mr Jackson while the latter was standing on the footboard of the carriage. Are you a man who kind of integrate he seen things? (Laughter)—No, I do not as a rule.

Browne then went on to mention to Mr Jackson that—I do not know about that.

Constable Anderson spoke to having been on duty in the Joint Station on the morning in question, and of effecting the arrest of the accused. Miss Browne had broken away from the police officer after he had given her into custody, and she had struck him with her fist.

Miss Fassell, organiser, Aberdeen branch, W.S.P.U., gave evidence as to calling on Mr Jackson and offering an apology which her minister would not accept.

COMPENSATION FOR MISTAKE.

Miss Browne declined to go into the witness-box and make her statement on oath. She thought she should not have been charged with assaulting Mr Forbes Jackson, as she ____ never intended to do and that she intended to for an doing. With regard to Mr Forbes Jackson, she was very sorry when she found out that she had made a mistake, because of an account that this mistake had been made, she considered herself ____ hoped that Mr Forbes Jackson himself would have been subjected to no great discomfort on what had occurred, and that if a minister the circumstances he had suffered she would have been sorry for by the suffragettes. She sincerely trusted that Mr Forbes Jackson had been somewhat compensated by having excellent congregations.

CHANCELLOR'S ABERDEEN DOUBLE.

Dec 1912

Our photo shows the Rev. Forbes Jackson, Crown Terrace Baptist Church, Aberdeen, ____ was assaulted this morning at the Joint Station by an excited suffragette, in mistake ____ Mr Lloyd George. It will be seen from ____ photograph that the likeness between the t____ gentlemen is most striking.

The *Morpeth Herald* of 16 May 1916, showing how the local group 'condemned and deplored' the 'outrages' committed by the more militant campaigners. Into this sedate atmosphere arrived Emily Wilding Davison, whose criminal record included a long list of just such protests. (Mackay Archive)

WOMAN'S SUFFRAGE.

A well-attended meeting in support of woman's suffrage was held last evening in the Town Hall, Morpeth, under the auspices of the Morpeth Society for Women's Suffrage. Mr. F. Brumell presided and was supported on the platform by Fru Anker, of Norway; Miss I. Beaver, Rev. Canon Davies, Rev. James Haworth, and the Mayor (Ald. R. J. Carr).

The Chairman referred to the non-party and non-militant character of the society. On the latter point, he said they condemned and deplored the outrages which had been committed by a small party of women who claimed to be acting on behalf of the women's cause. The whole line of policy and conduct pursued by those women was injurious to the best interests of the cause they claimed to be assisting.

Fru Anker, speaking English fluently, gave a very interesting account of the suffrage movement in Norway, where women have had the vote for some years. She said that during a national crisis at the time of the Napoleonic wars the first public demand for the vote was made by a woman. The grand-daughter of this woman was the first lady member of Parliament in Norway. John Stuart Mill's writings, particularly his book "The subjection of Women" gave an impetus to the movement. The first suffrage union was formed in 1885, and twenty years later, the women of the country by their patriotic attitude during the crisis with Sweden, won for themselves the vote. They had already voted in two elections, and their influence on the side of reform was acknowledged by all parties, who, Fru Anker significantly remarked, were all eager now to claim credit for extending the franchise to women.

Miss Beaver also gave an address, and a resolution in favour of votes for women was carried.

Mr Jeffreys of Morpeth and Longhorsley explained to me, over a cup of tea, what was happening in the Davison's lives at this time. Emily's mother had particularly asked Emily not to discuss her activities with anyone in Longhorsley, but Emily's conversations with the local vicar and the doctor meant that the 'backstairs gossip' in both the vicar's and the doctor's households inevitably got back to her mother's shop, and the ensuing village confrontations were becoming a problem. Mrs Jeffrey is a Caisley/Waldie descendant of Margaret Davison (*née* Caisley), Emily's mother. Margaret was the sister of Mrs Jeffrey's great-grandmother Jane Waldie (*née* Caisley).

The corner shop was quite modest. It only really had accommodation for Margaret and a resident live-in companion, but she still stoutly supported Emily in every way: Margaret Davison's unwavering commitment to Emily's campaigning can be seen from a New Year's message published in the 1917 *WSPU Magazine*, four years after her daughter's death: 'From the mother of Emily Wilding Davison, With Greetings, and I trust and hope the Woman's Movement will be a great success in the near future.' However, both women badly needed their own space. Therefore, Margaret's daughters Letitia and Emily, when visiting, stayed in rooms across the road in The Shoulder of Mutton, the village inn. Mr D.J. and Mrs E. Jeffrey of Morpeth and Longhorsley, whose family were the publicans of the Leg of Mutton in 1913, told me about this time: 'Emily and her sister Letitia would rent rooms in my grandfather's public house and, with their mother Margaret, spend their evenings talking to my grandmother.' Emily's cousins Gladys and Emily Wilkinson shared the responsibilities of being 'Aunty Meggie's' companion, helper – and often her first line of defence.

The Morrison, Davison and Bilton families in general had very complicated family and business relationships within Alnwick and Morpeth at this time,

Local news items, placing suffrage news alongside 'women's interest' sections such as knitting. (Mackay Archive)

and Bro. Watson said a few short words in regard to the Barrington Temple. The following temples in the district were represented:—George Dodds, General Gardon, Campbell-Bannerman, and Edward Elliott. After a short discussion on the various phrases of the district, the session was formally closed by the president.

WOMEN'S SUFFRAGE AT CAMBO.

On Saturday last, a meeting was held in the Institute, Cambo, by the National Union of Women's Suffrage Societies. The meeting was very well attended, and the audience appeared much interested. Miss Beaver, who was in the chair, explained that the National Union was the original suffrage society, and was started in 1857; and that its methods were entirely constitutional and non-party. Mrs. Biltcliffe then proposed a resolution calling upon Mr. Fenwick to do all in his power to obtain the inclusion of women in the new Reform Bill. She explained that politics was a woman's question—that it entered into her life and affected the conditions of her life whether she wished it or not. She referred to the domestic character of present legislation, e.g. the Children's Charter, upon which woman's advice would be most helpful. Mrs. Biltcliffe then dealt with the arguments of the anti-suffragist. She said that it was absurd to say woman's place was the home when many women were forced out of their homes for the labour market in order to be able to live at all. She thought that the people who were opposed to Woman's Suffrage because of militancy were confusing principle and method. One had to judge of a thing on its merits and not on the behaviour of a few of its supporters. Miss Beaver, who followed, seconded the resolution and urged the meeting to support it unanimously. She spoke of the underpaid and sweated condition of the industrially employed women, many women in Birmingham having to sew on 300 hooks and eyes for one penny. She said she felt the present was a most critical time for Woman's Suffrage because there was before the House of Commons a Reform Bill which proposed to enfranchise every male of adult age and competent understanding, but not one single woman. If women were to be included it meant increased effort and increased work. Miss Beaver then enumerated the various Woman's Suffrage amendments which are likely to come before the House. The resolution was carried unanimously.

To make the lace, which is quite original pattern, a steel crochet hook No. 6 should be used, and No. 30 or 36 cotton. The Rose Square.—Make 6 chain and unite with the first loke. Then work 5 ch., put thread over hook and the latter into hole that is made. Then two holes are formed. Make 2 ch., treble into first hole, and so put till you have six holes. Make 5 treble and 1 double crochet into each hole. There must be six petals. Turn work on wrong

NO. 1631.

side, make 4 ch., and unite between the petals with a d.c. Turn work to right side and make in each made loop 6 tr. and 1 d.c. Then turn to wrong side, make 5 ch. and unite between petals as before. Turn and make 6 tr. and 1 d.c., then 1 d.c. into first stitch of next petal. This finishes the rose.

Now make 12 ch. ... tenants of the chain to middl... of next year. The ... next petal. Make 12 ch... were accorded to his with a d.c. into the wid... Mr. Parsons third petal; 12 ch... atulating the club on of fifth petal; 12 ch... for next season. He in hole where first... organised by the lady 6 eight and se... ride sufficient funds to leaving the space... balance and leave a and make 12 ch... equip the new field, third d.c. from sev... an increasing year by 4 ch. and unite... ground the outlook. which was left... In closing the report Then 12 ch. int... the officers and com- third; 12 ch. in... for the assistance into second picot... third; 12 ch. int... into 6th double cha...

STATEMENT.

...the financial secretary, ...cessor, the late Mr. R... ...en compelled through ...sign the position, and ...e was suffering bring- ...end the career of a ...ct. The accounts, re- ...riptions from 170 mem- ...te receipts, £4 5s. 2d.; ...d by the lady mem- ...miscellaneous receipts, ...e 12s. 2d. The season's ...£296 7s. 5d., this gave ...1d. on the season, and ...verdraught from £37 7s.

Mr. J. R. Parsons, ...was adopted.

...R PLAYERS.

...ounced that Mr. E. W. ...d to provide caps for ...rs of the first eleven, ...pted on behalf of the ...an, who duly thanked ...nerosity.

...OFFICERS, &c.

...cers for the ensuing ...lows:—Captain, W. ...A. Bateley and E. L. ...Mr. C. H. Cheeseman; ...Mr. A. C. Fawcett; hon. ...R. Parsons; committee, ...I. H. Davies, Rev. H. G. ...bson, T. McRae, T. W. ...ns, G. D. Young, and

...gratulated Mr. Spence ...e captaincy of the club.

...d the officers and com- ...istance they had given ...of office. ...Mr. W. D. Soulsby, sec- ...llan, a vote of thanks ...tiring officers and com- ...m responded. ...1 with a vote of thanks

...ATTING AVERAGES.

	Inns.	Highest score.	Aver-age.
...	17	71	24.8
...	11	42	18.5
...	11	40	15.1
...	18	39	11.75
...	17	31	7.8
...	13	53	7.4
...	11	19	6.3
...	12	32	5.8
...	14		5.1
...	13	13	4.4
...	12	15	4.4
...	12		3.4

8 Innings.

| ... | 5 | 43 | 30.66 |
| ... | 4 | 24 | 12.0 |

...LING.

	Wickets.	Average.
...UM,	37	7.2
...	33	11.0
...	13	13.33
...	30	14.0

A THOUGHT FOR THE WEEK.

Fate holds her best gifts till we show our strength o make her let them go.

HOW TO GET THICK, GLOSSY HAIR.

It does not matter how careful anyone may be of the hair, the tint is bound to come—often after some slight cold or trifling illness—when the hair loses its glossy, live appearance, and becomes brittle, thin and faded. This can be remedied by everyone and at once. There is nothing more easy to cultivate than the hair, if one only knows how.

Get a bottle of Harriett Meta's Hair Tonic, it costs 2s. 11d. (by post 3s. extra), and will start to better the hair from the second application. If the use of the complete bottle does not do all we claim for it, you stand to lose nothing. The chemist from whom you bought the bottle will refund you every penny you paid any time within thirty days, if you are not satisfied. When you buy the bottle he will give you a written guarantee to this effect, signed by himself.

If you will only use Harriett Meta's Hair Tonic according to directions, rubbing it well into the scalp, falling hair will cease to come out, dandruff will disappear, grey and faded hair will resume its natural colour, and where there have been thin places before there will be no abundant growth of thick, new hair. Mind you, this is guaranteed, A. G. Marshall, 43, Bridge Street, Morpeth; G. Fuggan, Leadgate House, Bedlington; and other leading Chemists everywhere sell and guarantee it.

NORTHUMBERLAND NEEDLEWORK GUILD.

The annual exhibition of clothing collected by the Northumberland Needlework Guild, which takes place alternately in Newcastle, Hexham, Alnwick, and Morpeth, was held in the Town Hall, Morpeth. The object of the guild is to distribute articles of clothing among the poor patients of charitable institutions of the county.

... entirely of velvet or velveteen intended to be worn with a coat, for nothing alters easily over velvet stuffs. Dresses of mixed materials being among the leading vogues, the latest way of making up the velvet coat and skirt suit is strictly in accordance with a prevailing fashion whim that touches all kinds of frocks.

Illustrated is one of the new velveteen coat and skirt costumes alluded to the smaller sketch showing the dress without the coat. At the neck is a sailor collar of velvet matching the hem, and there are cuffs and a narrow waistband of the same. The dress might be of soft figured silk or satin. The velvet coat is slashed with braid on the sleeves and front, and is also handsomely trimmed with braid at the neck and waist.

A SMART RED COAT FOR A GIRL.

Dressmakers who make a special feature of children's fashions are showing some very smart and pretty styles for the young, materials of great variety, including serge cloth, and sponge-cloth weaves. The colours used for children's

everyday frocks are, to a great extent, limited, those mostly played upon being navy-blue, red, and certain shades of green. A rather bright shade of fir-tree green is successfully used in the smart coat and skirt for a girl of about ten years of age, the material employed being freize cloth. This particular green is becoming to flaxen-haired girls, and shades better... while the stockings must be navy-blue coloured.

Very charming, again, for out of doors is the novel coat illustrated, suitable for a girl of about twelve years of age. The material composing the coat is red cloth, and the little straps decorating the front are plum...

No. 1637.

...follows:—Cut the white meat from the bones of the bird into nice squares, and boil the brown meat and bones with well-flavoured vegetables, herbs, and seasonings, to make stock. Allow this to simmer for several hours, then strain it into a clean saucepan, making sure that the flavour is good. Bring the stock to the boil, and add enough rice to absorb it. When the rice is well cooked put into it a lump of butter and stir it well. Then put the meat of the turkey into a small pan with a small piece of fat, a seasoning of pepper and salt, some very finely chopped parsley, chervil and shallot, and heat the whole well over the fire, stirring all the time. When quite hot, add it to the rice and stir both well together. The whole should then be piled high in the middle of a dish, smoothed over, and decorated with bits of crisply fried parsley. The addition of tiny wedges of fried bread is also approved of.

RE-SERVING THE PLUM PUDDING.

Plum pudding is rather a difficult dish to re-serve temptingly, but a nice way patronised by a clever young cook is to make up the remains of a pudding into a smaller basin or mould and re-steam the mixture. She also serves up plum pudding a second time by slicing it, cutting the slices into little outlet shapes, dipping them in egg and bread crumbs, and frying them. Into the end of each little outlet she sticks an almond to represent a bone. Mincemeat may be used for a change in place of jam, as the foundation layer for a rice souffle.

A THOUGHT FOR THE WEEK.

Sow an act, reap a habit;
Sow a habit, reap a character;
Sow a character, reap a destiny.
W. M. Thackeray.

LOCAL SUFFRAGETTE RELEASED.

Miss Emily Wilding Davison, the suffragette of Longhorsley, who was fined 40s. or 10 days' imprisonment at Aberdeen on Thursday week, for having assaulted with a whip an Aberdeen clergyman whom she had mistaken for Mr. Lloyd George, has been released from Craiginches Prison, for fine having been paid anonymously. During the four days she was in prison she refused food, and was, in consequence, in a weak condition when released. She stated that the prison authorities had been most kind in their treatment of her.

WHIST DRIVE AT ASHINGTON.

The annual whist drive and dance in connection with the Ashington Colliery office staff took place in the Harmonic Hall, Ashington, on Thursday last week. There was a very large company present, and the proceedings throughout were most enjoyable. Considerable interest was taken in the whist drive, which resulted in Miss Todd, Newbiggin, and Mr. Snowdon, Washington, being the first prize-winners, while the consolation prizes were won by Mrs. Leitch and Miss H. Coulson. At an interval Mrs. F. L. Booth presented the prizes to the successful competitors. Dancing was afterwards indulged in, and carried on until a great zest for several hours. An excellent programme of dance music was rendered by the Harmonic Band. The duties of M.C.'s were efficiently discharged by Messrs. Henderson, A. R. Fowler, W. Cookson, and T. Collins. The hall was tastefully decorated for the occasion. The general arrangements were carried out by Mr. W. Marshall.

ones that also linked them to Emily's extended family group. The family tradition of employing younger female relatives as housekeepers or companions within the various households was upheld by Emily Wilding Davison when she herself needed a housekeeper/companion. A young relative called Miss Morrison took up the position; she was later to be part of Emily's funeral cortège. This domestic aid would have given Emily greater independence (and the freedom to write and campaign) after Mrs Pankhurst's declaration of outright war against the government had increased the movement's belligerence.

For as 1912 became 1913, Emily began to increase her efforts to become a professional writer in order to support herself: in February 1913, Harriet Keir wrote to H.G. Daniels at the *Manchester Guardian* asking if he would 'see' Emily, as she was interested in journalism. In April, Emily inquired at the *Nursing Times* about the possibility of writing for that paper. Efforts continued till very shortly before her death: on 2 June, the Tax-Resistance League wrote to Emily to tell her that the position for which she had applied, that of junior shorthand typist, had been filled. They returned what they described as her 'dog-eared testimonials' (*see* Crawford, 1999).

Also in 1913, she received an undated family letter along with a postal order: 'A little something to keep you going,' it said. The following interesting remark was also included: 'I do think that the militants might remember your services and give you something...'

The Times of 22 October 1912 reported a speech given by Mrs Pankhurst in London the day before. In it, Emmeline attempted to explain and justify the suffrage movement's increasing militancy. The heading was 'rebellious suffragists'. 'As long as women were "outlaws,"' she reportedly said, 'they were justified in open rebellion.' Mrs Pankhurst further declared that 'the fight would be carried on, as before, with every regard for human life, adding that if there were any lives to be lost they would be their own.' She pointed out the unfair difference in the sentences handed down to some recent male looters and window-breakers in Ireland and their female equivalents in the capital. She then declared that she would 'never repudiate or disown any woman who was fighting in their cause'. She concluded with the thought that the great mistake of women in the past was that they 'had been too law-abiding'. As a contrast, local news coverage of suffrage items (and now the Aberdeen incidents) in the *Morpeth Herald* were always to be found alongside the knitting, stitching and cooking sections of the newspaper – which showed the significance that the local editor placed on such matters! Only in her death did Emily make the front page of the *Morpeth Herald*.

Relationships and Canvassing Local Politicians

Thomas Burt, the 'father of the House of Parliament', was the first working-class MP. A miner from Northumberland, he represented Morpeth, and in his many years of service he eventually became a privy councillor.

Leaving my doctor's surgery three years ago, I noticed a young boy and his mother walking to their car. I explained that I was a genealogist, and that I'd noticed that their name, written on the noticeboard at the doctor's, was Caisley. The mother had heard, through relatives, about my research, and asked if she could come and see me. During our afternoon together, she asked me if I had made any link between her family and that of Thomas Burt, the famous local politican. Burt was the oldest MP in the Houses of Parliament. There is a marble bust of him on the staircase in the Town Hall, and her father had often pointed out the Miner's Union building in Newcastle, when they were passing, and told her that Thomas had once had an office there, and that she was related to him.

I confessed that I had not uncovered a connection so far, but that the local newspaper, and the Newcastle newspapers, noted that Emily once went to see him (with another suffragette called Miss Laura Ainsworth) to ask if he would support their cause. They canvassed all the politicians for their support in 1912. Laura lived at Wark-on-Tyne, near Chipchase Castle, and was one of Lady Mona Taylor's staunchest supporters.

Nor was Emily the only famous suffragette in the North East at this time: Lilias Mitchell was also in residence. Lilias was a Scottish suffragette who was sent to the North East by the WSPU to be their organiser. Both Emily and Lilias had recently left the Aberdeen area: an Aberdeen newspaper from December 1912 reports on Emily Wilding Davison's release from Aberdeen's Craig Inch Prison, whilst Elizabeth Crawford's *The Women's Suffrage Movement* shows that Lilias had moved from Aberdeen to the North East in December 1911. The two women were to meet in Morpeth shortly afterwards.

Lilias was formerly the WSPU's organiser in Aberdeenshire. Mrs Pankhurst declared that male sports and sporting venues were to be considered legitimate militant targets – and so Lilias, with a small group of women, successfully carried out a daring night-time raid on Royal Balmoral golf course during the Prime Minister's visit, changing the golf flags on the tees for flags bearing the suffrage colours. Her team handmade the eighteen suffragette flags, each defiantly flying the green, white and violet (purple) which spelled out 'give women the vote' (the first initials of green, white and violet). Scottish golf courses had only minimal police protection, making the raid a complete success. (See the work of Stirling University's Dr Joyce Kay, such as *The Wild Women* and *Female Violence against Male Sport*, for more on this.)

Morpeth Herald, 4 October 1912.
(Mackay Archive)

WOMAN SUFFRAGE.

MR. T. BURT'S REPLY TO A LOCAL DEPUTATION.

Miss Laura Ainsworth and Miss Emily Wilding Davison, of the Women's Social and Political Union, had an interview with Mr. Thomas Burt, M.P., at the Burt Hall, Newcastle, to obtain his views on the Franchise Reform Bill. Mr. Burt intimated that he would vote for amendments to give the suffrage to women. Asked if he would bring pressure to bear on the Prime Minister to induce him to embody woman suffrage in the Bill, Mr. Burt's answer was in the negative.

The WSPU, never slow to miss an opportunity, would have realised the huge potential in carrying out a further high-profile sporting protest at Epsom in the coming summer. The Derby would give them maximum publicity because, like Balmoral, it had a royal connection: Anmer, the King's horse, was there, and he was to be ridden by the 'royal jockey', Herbert Jones. It was an ideal sporting target, and Emily Wilding Davison and Lilias Mitchell's experience made them the ideal choice to organise the protest. (With the benefit of hindsight, we now understand that it was no coincidence that Lilias was moved to the North East to become the Newcastle WSPU organiser in this critical period. Further weight is added to the argument when one realises that Lilias Mitchell, after the tragedy of the Epsom protest in July 1913, was quietly spirited away out of the area: she moved to Birmingham, where she then became the militant organiser in the Midlands.)

The local Suffrage Society's meetings in St James' Hall in Well Way initially attracted only local speakers, but subtle changes began to happen in and around the town once Emily and Lilias combined forces. They began to recruit their own coterie of like-minded, determined, down-to-earth Morpeth women. So the target was chosen, and Morpeth's newly militant suffragettes began to gather on the common. There were local people who would have made it their business to keep 'tabs' on the women. Thereafter, the women were often seen together on the common, circling their horses past a group of local suffragettes. Each woman would reach up to the bridles as the horses passed, suffrage ribbons held in their hands. John Sleight's *One Way Ticket to Epsom* includes this story. It is clear that the women were hoping to attach a ribbon to a horse at the Derby. However, all sources say that the horses were not being *raced* past the suffragettes: they were being exercised quietly, as if they were in the paddock before the race. That is a significant point: I believe that something must have gone drastically wrong at Epsom, and that Emily's original plan had been to get into the paddock before the race. There, she would not have needed to reach up to the top of the horse's head: the bridle pieces near its mouth would be the easiest to get to. The racehorses, of course, would have been used to people approaching them, so if done quietly (and deftly) the horses would not be startled by someone coming close to them, holding up their hand and softly threading something – the suffrage colours – through the bridle straps and metal fittings. This seems the most likely approach

Emily, writing at her desk, in the last years of her life. (Courtesy of Pat and Gordon Shaw)

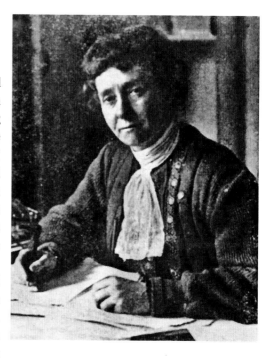

to their plan. Had Emily had to make a hurried change to a riskier 'plan b', and in so doing taken a calculated risk? One thing seems certain: none of those down-to-earth, canny and independent Northern women would ever have been party to a suicide plot. It therefore seems certain that Emily's death was nothing but a tragic accident.

Every student of political and women's history is well aware that Emily Wilding Davison died, in the summer of 1913, from the injuries she received during a suffrage protest on the racecourse at Epsom on Derby Day, but the existence and involvement in this protest of a group of local Northumbrian women – a group whom she both inspired and actively encouraged, and who began planning the protest up to eighteen months prior to her death – has been carefully hidden for almost a century. There is, and always has been, documented evidence that there were other suffragettes raising banners and placards in the crowd directly behind Emily Wilding Davison at Tattenham Corner: this fact was acknowledged by a police officer at the coroner's inquest into her death. This too must disprove the idea that Emily was acting alone, and had gone to Epsom on her own initiative.

Another astonishing discovery I made was the way that Emily was chosen. Who would be going down to Epsom to carry out the protest? All were keen and eager, so a fair way of choosing someone was arrived at: they would choose straws. The one who chose the shortest straw would be the one who carried out the protest. Emily was fated to be the one that picked the shortest straw, and thus it was by pure chance that she made the journey south to Epsom.

The fact that Emily had bought a return ticket to Epsom is of course well known – until recently, it could be seen in the Women's Library in London. Another item was found beside it. On 23 March 1913, in St Malo, the youngest child of Letitia (Emily's sister) and Frederick De Baecker was born. In Emily's purse at Epsom was found a letter from Letitia saying how difficult it was – the baby cried all night, which the pair were finding very stressful. Emily, before she left for Epsom, had let it be known to her cousins and friends that she was looking

forward to going to France to help her sister with the young baby, a new relative that she had not yet seen. This is another indication that Emily had no intention of dying on the track.

Flying the Flag

The symbolism behind the flying of the suffrage colours, as also seen at Balmoral golf course, should not be underestimated: the use of symbolism was an effective tool, and was often used by the suffragettes to subliminally get their messages across. It was this colour scheme that the group planned to attach to the King's horse. After the successful Balmoral protests, the North East's suffragettes were eager to join in the nationwide campaign against male sports – with the added strategy of using their suffrage colours to highlight their petition to their King.

To the women brought up in the North East, those who were planning the Epsom protest, raising the suffrage colours had a deeper meaning too. From infancy they would have been told of the story of local hero Jack Crawford (1775-1831), a keel man (small shallow-drafted boats which carried coal out to larger boats moored in deep water) from Sunderland who had been pressganged into the Royal Navy and became the hero of the Battle of Camperdown in 1797. Crawford was serving on Admiral Duncan's flagship, HMS *Venerable*. After the ship's top mast was shot away and the ship's colours (with the admiral's flag) thrown to the deck, Jack sprang into action. He knew that the lowering of the colours meant the ship's surrender, so he quickly freed the flag from amongst the mangled wreckage of the mast and began climbing aloft, amidst shot and cannon-fire, to nail his ship's colours back to what remained of the mast. He was cheered on by the ship's crew as he climbed, all of whom cried 'no surrender' when Jack re-joined his shipmates on the deck. The battle cry of 'no surrender' was to become the mantra of the militant suffragettes – in fact, Emily Wilding Davison herself cried it to her comrades in the public gallery as she was escorted from the dock on her way to Aberdeen's prison.

As soon as she recovered her health, Emily began planning an act that would draw maximum attention and publicity to the Suffragette Movement.

Derby Day

WEDNESDAY, 4 JUNE 1913: Derby Day. Many theories have been put forward to explain this famous day's events. One of the most reliable sources is the evidence given at the coroner's inquest. From witnesses' statements, it seems very likely that Emily was accompanied to Epsom by a group of local suffragettes. According to the evidence given at the Coroner's Court, a group raised placards behind her as she entered the course and shouts of 'votes for women' were heard. London suffragettes who knew Emily later stated that they had not known of any proposed protest – so who were these suffragettes in the crowd? Why didn't the investigating officers try to trace them? Is it possible that some of her Morpeth women came to the racecourse, and that they were whisked away to safety after the plan went so drastically wrong?

John Sleight's book notes that a group of suffragettes were seen with Emily on the platform at Morpeth. It has always been assumed that these women were a farewell party – a similar group usually went to the station when Emily was about to launch a protest, usually carrying the suffrage banners for 'Northumberland's Hunger Striker'. What if this time some of the women at the station accompanied her to Epsom?

What happened at the racecourse? If, as seems likely, Emily really intended to pin the colours to the King's horse in the paddock, why did she change to what was obviously a much riskier 'plan b'? Emily's family and I have now come to believe that the most likely reason for the change was that Emily was a victim of her own notoriety: her face had recently appeared in newspapers from London to Aberdeen, and so perhaps she was simply too well known to carry out the protest as first planned. Indeed, it may have been impossible for her to get into the paddock unrecognised: *The Times'* report the next day listed the race-goers in the Royal Circle, who included Lord Grey. He would have known exactly who Emily was – if he had seen her anywhere near the paddock or the royal family, he would have guessed her intentions immediately. In 2003 Moira Hughes of Mooroolbark put forward another of the families' theories – that Lord and Lady Layland-Barratt (who, of course, Emily had once worked for as a governess) were also there that day. I have not found documented evidence to support this, however, so for now it remains oral history rather than documented fact.

Given that the plan, for whatever reason, could not go ahead, why didn't she simply abandon the whole thing? What was so important to the women, and to Emily, that meant she was prepared to take such a dangerous (but calculated) risk? Possibly it was simply pride and loyalty – which, in Emily, as family legend tells us, was legendary. Perhaps she did not want to let anyone down. Despite what history has led us to believe, Emily was a fit and active woman, sure of her own physical abilities: her postcards to her cousins, and Letitia's letter in 1934, reveal her sporting and athletic prowess, and her abilities at swimming, tennis and cycling. Did she really think that she had the strength and ability to dash, hell for leather, onto the course and still be able to carry out a variation of the practised protest? Or, from where she was at Tattenham Corner, did she mistakenly assume that all of the horses had passed her by – and that all she had to do was to get to the Pathé News camera and raise the colours? That would have been an ideal way to show the world that the North was just as capable of carrying out Mrs Pankhurst's orders as the South, and to declare that their protest, at the most prestigious sporting event in the calendar, was just the beginning of their suffrage campaigns.

This was Morpeth's very first militant protest. It was meant to send a clear message, their unique battle cry of 'no surrender' representing the North's fighting spirit just as Jack Crawford had done at the Battle of Camperdown. Was this local pride behind the tragedy that was about to occur? If successful, this very high-profile sporting protest would have eclipsed every other suffrage protest: perhaps they felt that it was worth the attempt, no matter what the cost.

As history remembers, it cost Emily her life. She was badly hurt at Epsom and, although feared dead at first, she was taken to Epsom Cottage Hospital in a private automobile – according to the police notes, she was picked up from the track by the driver. Unconscious, she was examined. There her identity was first suggested to the world: her clothing was found to be labelled 'E. Davison'. She was believed to be Emily W. Davison, but up to a late hour on Wednesday no one had called to confirm this.

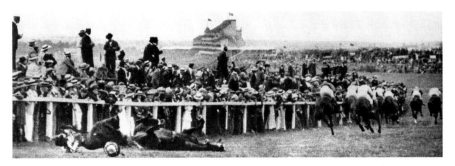

The moment that history remembers: the King's horse falls with Emily, an accident that was to cost her her life. (THP)

Emily's Last Moments

Professor June Purvis kindly pointed me towards some online resources that describe Emily's last moments. The Spartacus Educational website quotes a fellow suffragette called Mary Richardson, who later claimed to have been at Epsom with Emily:

> A minute before the race started she raised a paper on her own or some kind of card before her eyes. I was watching her hand. It did not shake. Even when I heard the pounding of the horses' hoofs moving closer I saw she was still smiling. And suddenly she slipped under the rail and ran out into the middle of the racecourse. It was all over so quickly.

Other sources, such as the English Women's History website, say that Mary was then chased by an angry crowd all the way to Epsom train station. I believe that there is a very real possibility that Mary Richardson has been confused with Mary Leigh, Emily's militant friend, who visited the grave every year until advanced age prevented her. The confusion between the two women arises from the fact that on one website Mary Richardson is described as being a WSPU Pipe Major, but this was actually Mary Leigh.

Another site – www.historylearningsite.co.uk/derby_of_june_1913.htm – has more to share about Emily's last moments. It says that Emily stopped in front of the King's horse and attempted to grab the bridle, a theory that the King's jockey later confirmed. It gives two eye-witnesses statements, both people standing at Tattenham Corner. The first said:

> I was watching the horses approaching Tattenham Corner, when I noticed a figure bob under the rails on the opposite side to which I was standing. The horses were thundering down the course at a great pace bunched up against the rail. From the position in which the woman was standing it would have been impossible for her to have picked out any special horse. It was obviously her intention to stop the race. Misjudging the pace of the horses she missed the first four or five. They dashed by just as she was emerging from the rails. With great calmness she walked in front of the next group of horses.
>
> The first missed her, but the second, Anmer, came right into her, and catching her with his shoulders, knocked her with terrific force to the ground while the crowd stood spellbound. The woman rolled over two or three times, and lay unconscious. She was thrown almost on her face. Anmer fell after striking the woman, pitching Jones, the jockey, clear over its head. Fortunately, Anmer fell clear of the woman, and the horses following swerved by the woman, the jockey and the fallen horse.

The second, John Ervine, said:

> Ms Davison, who was standing a few yards from me, suddenly ducked under the railings as the horses came up. This was very near Tattenham Corner, and there was a very large crowd of people on both sides of the course.

The King's horse, Anmer, came up and Ms Davison went towards it. She put up her hand, but whether it was to catch hold of the reins or to protect herself I do not know. It was all over in a few seconds. The horse knocked the woman over with very great force, and then stumbled and fell, pitching the jockey violently onto the ground. Both he and Ms Davison were bleeding profusely, but the crowd which swarmed about them was immediately too much for me to see any more.

I feel sure that Ms Davison meant to stop the horse, and that she did not go on to the course in the belief that the race was over, for, as I say, only a few of the horses had gone by when I first saw her leave the railings, and others had not passed when she was knocked down. I could not see whether any other horses touched her, for the whole thing happened so quickly, and I was so horrified at seeing her pitched violently down by the horse that I did not think of anything. The affair distressed the crowd very much.

Spartacus also quotes the Pankhursts' reactions to the tragedy: Sylvia Pankhurst said that Emily 'concerted a Derby protest without tragedy – a mere waving of the purple-white-and-green at Tattenham Corner, which, by its suddenness, it was hoped would stop the race ... she would not thus have died without writing a farewell message to her mother.' In contrast, Emmeline believed that: 'Emily Davison clung to her conviction that one great tragedy, the deliberate throwing into the breach of a human life, would put an end to the intolerable torture of women. And so she threw herself at the King's horse, in full view of the King and Queen and a great multitude of their Majesties' subjects.'

This second view, of course, I do not share, nor do Emily's family members.

The next day, Thursday 5 June, Dr W.B. Peacock treated Emily for what *The Times* described as a 'concussion of the brain'. She rallied a little during the day and took some nourishment. Scotland Yard then arrived. The Queen also sent a messenger to find out the condition of the suffragette.

On Friday, 6 June, the very next day, Mrs Pankhurst and her 'militant suffragists' came to face trial at the High Court of Justice, King's Bench, London. All the while, Emily's condition was worsening. An operation was performed as her condition grew critical. The surgeon was Dr Mansell-Moulin, then vice-president of the Royal College of Surgeons. His wife, Edith Ruth Thomas M. Moulin, was the first treasurer of the Church League for Women's Suffrage and a friend to Emily. As her condition became critical, her relatives were called. Due to the distances involved, it was decided that Margaret, Emily's mother, should remain in the North and begin planning for her daughter's funeral arrangements, should the worst occur. However, everyone knew that it was just a matter of time. Margaret firmly stood her ground against the suggestion, put by the members of the WSPU, that Emily should be buried in London. She insisted that Emily return to Morpeth.

HIGH COURT OF JUSTICE.

KING'S BENCH DIVISION.

ACTIONS AGAINST MILITANT SUFFRAGISTS.

(Before Mr. Justice Darling and a Special Jury.)

Five actions consolidated by order of the Court and brought by Robinson and Cleaver (Limited), Swan and Edgar (Limited), Swears and Wells (Limited), the White House Linen Specialists (Limited), and T. J. Harries and Co. (Limited) against Mr. and Mrs. Pethick Lawrence, Mrs. and Miss Christabel Pankhurst, and Miss Mabel Tuke, on her own behalf, and as representing the Women's Social and Political Union, came on for hearing. Damages were claimed from the defendants for wrongfully and maliciously conspiring and combining amongst themselves and/or amongst the members of the Women's Social and Political Union to procure certain members of the said union to commit trespass and damage to goods and property of the plaintiffs.

Mr. Tindal Atkinson, K.C., and Mr. Charles appeared for the plaintiffs; Mr. George Wallace, K.C., and Mr. Blanco White appeared for Mabel Tuke only as representing all members of the Women's Social and Political Union. Mr. and Mrs. Pethick Lawrence and Mrs. Tuke appeared in person. Mrs. Pankhurst had not put in any defence to the actions, and Miss Christabel Pankhurst had not been served with the writs.

Mr. Tindal Atkinson, in opening the case for the plaintiffs, said that the action was one for conspiring to procure certain persons to break windows of the plaintiffs which were broken systematically on March 1, 1912. The plaintiffs' windows had been insured, and the damage had been paid for.

Mrs Pankhurst comes to court: all of this was happening at the same time as Emily was fighting for her life. (Maureen Howes)

Saturday, 7 June: Emily's friends and various suffragettes arrived at the hospital. Letitia, her sister, left her three-month-old baby in France to get to her sister's bedside, along with a friend of her mother. The two were waiting for Captain Henry Jocelyn Davison, Emily's half-brother, to arrive as the family's representative. Emily's WSPU friends had decorated her bed with suffrage colours before the family arrived. However, when Captain Henry and Letitia arrived they felt uncomfortable with such a blatant display of Emily's political views. They wanted their sister to be left with them in peaceful surroundings, and the items were therefore removed on the family's orders, some to be salvaged as souvenirs by the staff at the hospital.

The next day, a Sunday, Emily died, at 4.30 p.m. No family were then present.

The next day, Monday 9 June, the WSPU proposed a public funeral, with the burial to take place in Morpeth.

Tuesday 10 June saw the inquest called at Epsom Courthouse. Captain Henry Davison RN (retired) was asked: 'Did you know anything that would lead you to think that she [Emily] was abnormal mentally?' The captain replied, 'nothing'. The verdict was 'death by misadventure'.

Although many of the women had put themselves in danger with hunger strikes, Emily Wilding Davison was only the suffragette who deliberately risked death.

However, even this tragedy did not entirely win over public sympathy – some sources appeared to be more concerned with the health of the horse and jockey and condemned Emily as a mentally-ill fanatic.

Some public sympathy was however evident in the thousands of people who lined the streets to watch as Emily's funeral cortege travelled to a memorial service in St George's church, Bloomsbury. As her body was brought back to Morpeth by train, scores of people stood at railway stations to pay their respects. During the train journey, suffragettes kept vigil in the carriage carrying the coffin and were met in Morpeth by Emily's family. Local people flocked into Morpeth in their hundreds to pay their respects to Emily Wilding Davison, and photographs show them lining the road from the Station to St Mary's church, where she is buried.

Emily Wilding Davison died at the age of forty. She has left her mark on history and will be remembered as a woman who gave her life for her beliefs.

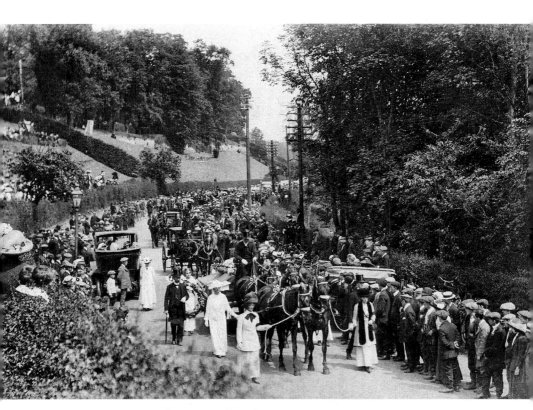

Funeral procession at Morpeth. (Maureen Howes)

Was Emily Engaged at the Time of Her Death?

In October 2002 I placed an article in the *Morpeth Herald* asking for help in finding the present-day family members, and for photographs and anecdotes relating to Emily. The first members of the family to contact me were the descendants of the Caisley/Wilkinson family line, the grandchildren and great-grandchildren of Emma Caisley. Emma was the youngest sister of Margaret Caisley, who married John Henry Wilkinson. In those first few weeks of research I was totally unprepared for the wealth of material that I was being presented with as they arrived at my door. I was shown — and held in my hands — a variety of material and precious family items, all individually unique and all with a story to tell us.

On my dining room table at various times were the Davison children's christening gowns, photographs, Emily's prayer book and *Pitman Shorthand Tutorial* book, a silver-topped gunpowder flask (inscribed George Davison, Alnwick, 1822), letters and unpublished photographs. The most breathtaking of them all was Emily Wilding Davison's beautiful emerald and diamond ring. Much speculation has been raised about this precious article, and with the mists of time we have almost lost its significance, and its possible link to the Aberdeen 'gift stone' that was ceremoniously placed on Emily's grave by 'a loving Aberdeen friend'.

The gift stone was placed on the seat beside the coachman waiting for Emily's funeral train to arrive at Morpeth station. The stone was to be placed on her grave. Only the family knew who had commissioned it, and from fragments pieced together within the various family groups it is now thought that it may have been sent by Emily's fiancé. The pair may have become betrothed in 1913, and he is thought to have been older than her, a fellow suffragist and an MP. He backed away from the limelight when the media arrived, and left, as his parting message, the words on the gift stone that had arrived from Aberdeen on the day of Emily's funeral.

Some have assumed that the person who commissioned the gift stone and the woman named Morrison in the first coach were the same person — but that has led them in the entirely wrong direction. As yet, apart from the evidence of the ring, the identity of Emily's 'loving Aberdeen friend' remains unknown. There may be those in the family who unwittingly have access to more clues, and we may yet solve the mystery.

Arresting Mrs Pankhurst

A FASCINATING SIDE-STORY emerged as I researched Emily's funeral. As is well known, Mrs Pankhurst was arrested as she tried to attend Emily's funeral – but the reasons for her arrest have, until now, remained rather obscure.

Carolyn Collette, my friend and colleague in the USA, is working on collating the letters and writing of Emily Wilding Davison, and we often work quite closely together in our shared interest in Emily. Carolyn found a 1912 letter from Emily in which she mentions that she is to be the guest speaker at a bank's debating society. This sparked our interest: what did Emily say that day? I contacted the archivists of the five big banks which have swallowed up all the smaller banks since Emily's day. Did they have any minute books from the bank's social clubs or debating societies? I received an email from Wythenshaw in Manchester, where the Barclays Group Archives are held. Their archivist, Kate Raine, told me that she couldn't offer me any more on Emily's talk that day – but 'would I like the WSPU bank accounts'? I certainly would! Though Emmeline Pankhurst, Carolyn confirmed, did not keep any accounts – it had long been thought that there were no accounts to be found and that probably she could not be bothered with things like that – we could have copies of the WSPU accounts, the 'Votes for Women' accounts, The Women's Press accounts and some other papers. All had been copied by the branch manager of Barclay & Co. Ltd, Goslings Branch, No. 19 Fleet Street. The story which then unfolded is one which beggars belief. It is a tale which ends with Mrs Pankhurst's arrest as she stepped through her door to go to the funeral of Emily Wilding Davison.

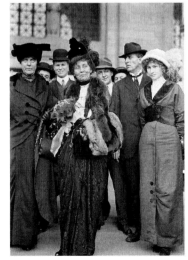

Mrs Pankhurst in late 1913, on her American tour, with Miss Lucy Burns of the CUWS (Congressional Union for Women Suffrage). (George Grantham Bain Collection at the Library of Congress, LC-DIG-hec-03440)

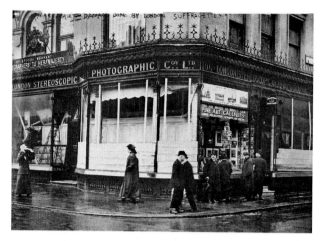

LEFT The damage done by the suffragette campaign against windows can be seen at this London store. (George Grantham Bain Collection at the Library of Congress, LC-DIG-ggbain-10220)

BELOW Another store attacked as part of the WSPU's protest. (George Grantham Bain Collection at the Library of Congress LC-DIG-ggbain-10194)

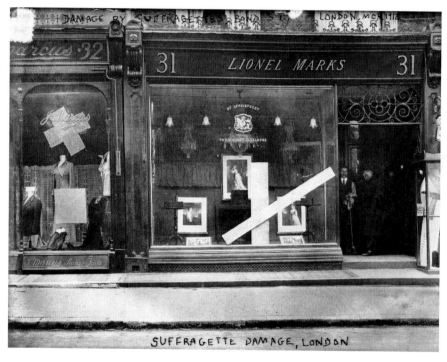

It is difficult for us, today, to place ourselves in the suffragists' shoes, and to imagine living in a world in which women were entirely without a voice. Further, the true story of the campaign for women's suffrage has often been obscured by the prejudices of the media of the age, which loved to present the suffragettes as the villains of the piece, and sometimes by deliberate 'cover-ups' too. Take the example of the background to the window-smashing campaign in London's West End. We now know that this campaign was an attempt to draw attention to the government-sanctioned brutality meted out to suffrage campaigners on

Black Friday. Black Friday began when a deputation of 300 women attempted to present a petition to the Prime Minister. Instead, the group was forced to run the gauntlet of police and jeering crowds, who funnelled them down cul-de-sacs and side streets. For six hours, the women were trapped in narrow streets with no escape. They were manhandled, beaten, kicked, and in some cases sexually assaulted by the police. Two suffragettes would later die from their injuries: Cecelia Haig and Henrietta Williams. This happened in our capital, in broad daylight, to defenceless women. Doctors, medical students and nurses cared for the injured in Caxton Hall, where the women were treated for shock, blackened eyes and dislocated bones – and more serious injuries besides. Some of the women still returned to the fray, in a continued effort to get their petition to their Prime Minister.

In order to draw attention to what had happened, a campaign of window smashing began in London's West End in March 1912. As a result of the cover-up, the window-smashing campaign has been greatly misunderstood; the authorities had the power to cover up their own brutality, and to stop pictures of the incidents being shown in the newspapers. Churchill, for example, would not allow an enquiry, and stopped the newspapers printing the photos of the injured women and discussing the brutality of the police. (See Sylvia Pankhurst, *The Suffragette Movement.*) With the reason for their retaliation suppressed, Londoners did not make the link between Black Friday and the increased militancy disfiguring the capital. The window smashing was seen as violence for violence's sake – yet in reality the militants felt that it was the only recourse left to them to highlight their complaint. Breaking window panes, it seemed, was more offensive in the eyes of the nation than the breaking of women's bones. Ironically, it proved safer for the militants, using catapults, to break windows in protest than it was for them to approach the Prime Minister in a peaceful petition.

After the campaign against London's shop windows, the WSPU were sued for damages, and the manager of Messrs Barclay & Co. therefore had to supply the court with the various accounts. All of this occurred during the week of Emily Wilding Davison's funeral. The plaintiffs were 'the West End Clothiers Company Ltd and others'. The defendants were 'Emmeline Pankhurst (widow) and others'. Justice Darling and a special jury were sworn in to oversee the case. Mr George Wallace, KC, opened the case for the WPSU, and witnesses were called to prove that the union as a body was not responsible for what had taken place. The court of appeal then affirmed that the campaign against windows 'did not amount to "civil commotion"' and that therefore the damage done was not within the scope of an insurance against that risk. The case was held on 7 June and reported in *The Times* on 9 June 1913, either side of Emily's death. The result was 'a verdict for the plaintiffs for the amounts claimed by them was returned against all the defendants; and judgment was entered for the plaintiffs in five actions with costs.'

A range of letters and papers relating to the case. (Courtesy of Barclays Bank Archive, Wythenshaw)

Metropolitan Police Magistrate.	GEORGE THE FIFTH, by the Grace of God, of the United Kingdom of Great Britain and Ireland, and of the British Dominions beyond the Seas, King, Defender of the Faith, To *The manager, Messrs Barclay & Co. Ltd,*

19 Fleet Street, E.C.

and to every of them, Greeting: We command you and every of you that, laying aside all excuses and pretences whatsoever, you and every of you personally be and appear before *Henry Curtis Bennett* Esquire, one of the Magistrates of the Police Courts of the Metropolis, sitting at the *Bow Street* Police Court in the County of London and within the Metropolitan Police District, or such other Magistrate of the said Police Courts as may then and there be present on the *fourteenth* day of *March instant* at the hour of *quarter past ten* in the *fore* noon there to testify the Truth and give evidence on Our behalf against

Emmeline Pankhurst, Frederick Pethick Lawrence Emmeline Pethick Lawrence, and Mabel Tuke

upon a Charge of *Misdemeanour* and so from day to day until the said Charge be disposed of. And that you, or such of you in whose custody or power the same be, do bring with you and produce before such Magistrate aforesaid *The Banking accounts of*

(1) *Mr F. Pethick Lawrence, otherwise F. W. Pethick Lawrence*
(2) *Mrs Emmeline Pethick Lawrence, and such cancelled Vouchers*
(3) *The Women's Social & Political Union* *as may be in your possession*
From the 1st July, 1911, up to the present time

And this you or any of you are not to omit, under the Penalty of One Hundred Pounds, to be levied on the Goods and Chattels, Land and Tenements of you as shall fail herein. Witness RICHARD EVERARD BARON ALVERSTONE, at the Royal Courts of Justice, London, the *eighth* day of *March* in the year of our Lord One thousand nine hundred and *twelve*.

(50,708). Wt.39,879—2. 750. 1/12. A.&E.W.

Cut
11412.
Need not attend 1st May
Will advise me when wanted
Telephone 30/4/12

DIRECTOR OF PUBLIC PROSECUTIONS DEPARTMENT

Whitehall, S.W.
24th April, 1912.

REX v. EMMELINE PANKHURST, FREDERICK WILLIAM PETHICK LAWRENCE, and EMMELINE PETHICK LAWRENCE.

The Director of Public Prosecutions begs to inform the witnesses that this case will be taken at the Central Criminal Court on Wednesday next, the 1st May, at 10.30 a.m., when their attendance is requested.

Any further communication on the subject of this letter should be addressed to—
THE DIRECTOR OF PUBLIC PROSECUTIONS,
WHITEHALL,
LONDON, S.W.
and the following number quoted:—
_____of 19_____

WHITEHALL,
LONDON, S.W.

1st May 1912.

REX v EMMELINE PANKHURST,
FREDERICK WILLIAM PETHICK LAWRENCE
and
EMMELINE PETHICK LAWRENCE.

The Director of Public Prosecutions begs to inform the Witnesses that this trial has been postponed to Wednesday the 15th of May at 10.30 a.m. when their attendance is requested at the Central Criminal Court.

The Director much regrets ... inconvenience of which this postponement may be ...

In the event of any chan... requested to notify the Direc...

G. 6.

Subpoena Duces Tecum at Sittings of High Court.

In the High Court of Justice.

King's Bench DIVISION.

1912 . W No. 1774

BETWEEN *West End Clothiers Company Limited and others*

Plaintiffs

and

Emmeline Pankhurst (Widow) and others

Defendants

GEORGE THE FIFTH, by the Grace of God, of the United Kingdom of Great Britain and Ireland and of the British Dominions beyond the Seas, King, Defender of the Faith, TO* *Frederick Henry Seeley*
Manager of Barclay & Company Limited 19 Fleet Street EC.

WE command you to attend at the Royal Courts of Justice, Strand, London, at the sittings of the *King's Bench* DIVISION of our High Court of Justice to be holden on the *2nd 16th* day of *June* *Mon* day, at the hour of *10.30* o'clock in the *fore* noon, and so from day to day until the above cause is tried, to give evidence on behalf of the‡ *Plaintiffs* and also to bring with you and produce at the time and place aforesaid§

1. *Copy account of the Women's Social and Political Union from 1 July 1911 to 20th March 1912.*
2. *Copy of "Meetings account" for said period*
3. *Copy F.W. Pethick Lawrence account "Votes for Women" for said period*
4. *Copy F.W. Pethick Lawrence account "Women's Press" for said period*
5. *Cheque dated 29th February 1912 or Mrs F.W. Pethick Lawrence's Personal account for £1000 and payable to Mrs Beatrice Sanders*
6. *Cheque dated 1st March 1912 on the Women's Social and Political Union account for £7000 payable to Mrs Ayrton.*

WITNESS, RICHARD BURDON, VISCOUNT HALDANE OF CLOAN, Lord High Chancellor of Great Britain, the *16th* day of *May* in the year of Our Lord One thousand nine hundred and *thirteen.*

[7458] 5000 2/12 v G & S 1x68

<div style="text-align:right">

WHITEHALL,

LONDON, S.W.

8th. March, 1912.

</div>

> Any further communication on the subject of this letter should be addressed to—
> THE DIRECTOR OF PUBLIC PROSECUTIONS,
> WHITEHALL,
> LONDON, S.W.
> and the following number quoted :—
>of 19........

Sir,

 Rex v Emmeline Pankhurst, Frederick Pethick

Lawrence, Emmeline Pethick Lawrence & Mabel Tuke.

 I beg to inform you that I have instituted criminal proceedings at the Bow Street Police Court against the above named, for offences under the Malicious Damage Act, 1861, and that the accused stand remanded to Thursday next, the 14th. instant, at 10.30 a.m. at that Court.

 I am informed that your Company act as Bankers to:-

(1) Mr. F. Pethick Lawrence, otherwise Mr. F. W. Pethick

 Lawrence:

(2) Mrs. Emmeline Pethick Lawrence; and

(3) The Women's Social & Political Union;

the last named being the Association of which some of the accused, with others, form the Committee.

 As it will become necessary to produce in Court the Banking Accounts of the persons and Association named, I shall be obliged if you will be good enough to have prepared a copy of each Account as and from the 1st. July, 1911, up to the present time, and produced at the Court on the 14th. instant by an Officer of the Bank, for which purpose I am directing Chief Inspector Mc.Carthy, of New Scotland Yard, to call upon you with this letter, and serve a Subpoena in the usual way.

 In order to give you as little inconvenience as possible, by having one of your Officers in attendance at each remand, I venture to suggest that you should send me the copy Accounts referred to on an early date next week, and I would then be

Metropolitan Police Magistrate.

Spa.

GEORGE THE FIFTH, by the Grace of God, of the United Kingdom of Great Britain and Ireland, and of the British Dominions beyond the Seas, King, Defender of the Faith, To *The Manager Barclays Bank Fleet St*

and to every of them, Greeting : We command you and every of you that, laying aside all excuses and pretences whatsoever, you and every of you personally be and appear before *Henry Curtis Bennet* Esquire, one of the Magistrates of the Police Courts of the Metropolis, sitting at the *Bow Street* Police Court in the County of London and within the Metropolitan Police District, or such other Magistrate of the said Police Courts as may then and there be present on the *fourteenth* day of *March instant* at the hour of *half past two* in the *fore* noon there to testify the Truth and give evidence on Our behalf against *Emmeline Pankhurst, Frederick Pethick Lawrence, Emmeline Pethick Lawrence, Mabel Tuke, and Christabel Pankhurst*

upon a Charge of *Misdemeanour* and so from day to day until the said Charge be disposed of.
And that you, or such of you in whose custody or power the same be, do bring with you and produce before such Magistrate aforesaid *The Banking accounts of Mr Pethick Lawrence*

 (1) Mr Pethick Lawrence

 (2) Mrs Emmeline Pethick Lawrence

 (3) The Women's Social & Political Union

up to 20th March 1912 showing balance and such cancelled vouchers

And this you or any of you are not to omit, under the Penalty of One Hundred Pounds, to be levied on the Goods and Chattels, Land and Tenements of such of you as shall fail herein. Witness RICHARD EVERARD BARON ALVERSTONE, at the Royal Courts of Justice, London, the *fourteenth* day of *March* in the year of our Lord One thousand nine hundred and *twelve*.

(59,768). Wt.29,879—3. 750. 1/12. A.&E.W.

G. ARD. ROOK & Cº

W.C. SNOWDON CARD. LL.B.
STEPHEN A. CARD.
ERNEST A. DAVIDSON B.A.
TELEGRAPHIC ADDRESS
"HADRIAN, LONDON."
Telephone Nº LONDON WALL 1322.
Codes { A.B.C. 5TH ED."
WESTERN UNION.

2. Gresham Buildings,
Basinghall Street
London, E.C. 24th. May 19 13.

Dear Sir,

SUFFRAGETTES

WEST END CLOTHIERS CO. LTD. & OTHERS V. PANKHURST & OTHERS

Clients of ours have instituted proceedings against the leaders of the Suffragette movement to recover the cost of many of the windows damaged in the disturbances of November 1911 and March 1912.

We shall require the same evidence to be given as to the banking accounts of and in connection with the Womens Social and Political Union as was given by you at the Central Criminal Court last May on the prosecution of three of the defendants in this action.

Will you be good enough to let us have an appointment when we can call and see you and at the same time subpoena you to att...

11 o'c (Tuesday)

T.S. Grabham Esq.
Messrs Barclay & Co.Ltd.
19 Fleet Street
E.C.

In the High Court of Justice.

King's Bench DIVISION.

1912 P. No 1317
1912 ... No 2695
1912 ... No 2696
1912 W No 2148
1912 J No 7121

G. 6.
Subpoena
Duces Tecum
at Sittings of High
Court.

The Solicitors'
Law Stationery Society,
Limited,
22, Chancery Lane, W.C.,
49, Bedford Row, W.C.,
8, Victoria Street, S.W.

157-9.12.12 W205

Between Palmson & Cleaver Ltd & others

..

AND PLAINTIFF

Frederick Pethick Laurence & others

Consolidated by Orders dated 29 October 1912 & 12 March 1912.

DEFENDANT

George the Fifth, by the Grace of God, of the United Kingdom of Great Britain and Ireland, and of the British Dominions beyond the Seas, King, Defender of the Faith, To (¹) Frederick Henry Sealey of Barclays Bank, 19 Fleet St. E.C.

Greeting:

WE COMMAND YOU to attend at the Royal Courts of Justice, Strand, London, at the Sittings of the King's Bench DIVISION of Our HIGH COURT OF JUSTICE, to be holden on the 21st day of May 1913, at the hour of 1030 o'clock in the fore noon, and so from day to day until the above Cause is tried, to give evidence on behalf of the (²) Plaintiffs

and also to bring with you and produce at the time and place aforesaid (³)

Certified copies of account in the name of The National Women's Social & Political Union.

Certified copies of account " Votes for Women Account"

" " " " Meetings Account "

" " " " Womens Press Account "

Witness, Richard Burdon Viscount Haldane of Clean Lord High Chancellor of Great Britain, the 19 day of May in the year of Our Lord One thousand nine hundred and thirteen.

N.B.—Notice will be given to you of the day on which your attendance will be required.

After the Accident

I N 1918, five years after the accident, both Emily's brother Alfred Norris Davison and her mother died within ten days of each other (Alfred in a hospital in Vancouver, Canada, and Margaret in Longhorsley).

The daughter born to Emily's sister, Mademoiselle Marie De Baecker (daughter of Frederick and Letitia Charlotte Davison), grew up and got married on 4 June 1925 in Paris at the British Embassy Chapel. The groom was Monsieur Henry Stuart, Croix de Guerre, the son of Monsieur Charles Stuart OBE.

In 1939, at Christmas, Letitia Charlotte De Baecker wrote to Jessie May Bilton, her cousin. It was the outbreak of the Second World War, and Letitia said that she hoped her relatives in Northumberland would care for the family grave until she could return. She was seventy-one when the letter was written.

16 December 1939, Paris

This is to give you my best wishes for Xmas & the New Year. I am not sending any xmas cards and letters take such ages nowadays – I should love to hear how you all are & what you are doing – are you going up North? I can't believe it is near Xmas: it doesn't feel like it! It has been extremely cold & only a few days ago the place was heated ... I felt it acutely. What of yr boys? Gerald won't be called up: he did all the last war & has children.

Marie has been doing patriotic war work & I have tried to do a small 'bit' ... I wonder if you've seen Lizzie lately? I've not heard from her for months now: in fact I am not getting any English letters. I wonder if you've let your house: where are you living now? Do send me a letter with all your news. I always regret I can't send anything now to keep up the grave – didn't a relative of yours see to it? If so I am most grateful. I hope you are all well.

I send you my best love and every good wish,
Yours affect.
Lettie

From Paris in 1946 there is another family letter, written after the war by Letitia's daughter, Marie Stuart. It informs Jessie that Letitia did not survive the winter of 1943 in Paris:

3 Rue Henri Duchene, Paris
Dec 14th 1946

Dear Mrs Bilton,

Your letter has just arrived and I feel I must write at once and tell you the sad news. Mother passed away during the war on April 18th 1943. We had a fairly bad time during that winter and no doubt she suffered from it, but she was wonderful to the end, full of spirit; she was ill a month from weakness, against which we tried everything. Her loss is just as keen to me today as it was then. She only saw the darkest hours of the war but always remained confident. We often spoke of you all. I was in the Red Cross all through the war in Paris and am still in it. But going back to music by degrees – my husband is in Germany for the present working for the UNRRA. I spent some time in the summer with him in the French Occupied Zone.

I should be glad if you would give me news of yourself and the family. My best wishes to all for Xmas.

Believe me, yrs affectly.

Marie

Marie did take up her music again, and some of her Davison relatives were in the audience in London to hear her play.

Last year I was given a photo of Pierre De Baecker, the grandson of Letitia, and I am looking forward to meeting him and his family as the closest direct relative of Emily Wilding Davison, his English great-aunt.

The bulk of the archive that has given us this wonderful glimpse into the life of Emily the suffragette came from the Bilton Family Archive. We have to thank Jessie May Bilton's grandson Rodney Bilton for allowing us to see the world as Emily and her family knew it.

Pierre De Baecker at a meeting of the Franco-Scottish Society. (Courtesy of Nick Hide)

get away this summer. I had Mrs Gledson to see me on Whitmonday, of course Addie & George brought her in the car I was ever so pleased, as I never thought she would get this far & I only hope she hasn't suffered any ill effects. Addie is not too well, been looking after one of George's brothers whose wife is away in hospital & she's had too much work & George has had a lot of deaths & illnesses amongst his relatives so poor lass she's got run down, so I hardly dare hope to go there this year & I do like their place. I have had my grandson Peter "Babil's boy" for his half term weekend, he is at The Durham School but will finish just before Xmas then will have to do his military training before going to Cambridge University. He is six feet tall & such a nice boy, & considered good looking. I expect his Dad & Mam next Spring Lewis is still with me, his daughter Pat is now in the Civil Service in Harrogate & the boy Michael is nearly done school. Leslie's boy Rodney has just gained a free scholarship for The Grammar School here & we are all very pleased, it means a lot as there are no paying schools in Darlington where they can

This charming letter from Jessie May was written in 1952. It was found in the papers of a Wood family member, and brings the archival material to a fitting end. Here Jessie is writing to her cousins Lizzie and Charlie Wood. As you read, you realise that 'the more we change, the more we stay the same'. She is so proud of what her grandchildren have achieved, and she shares her hopes for their future. (Woods/Guidepost Archives)

get a finishing education. So I'm very thankful to be able to say we are, as a family, doing nicely & "I count my blessings". I often think of my cousins Woods & Wilkinson, & Caisley? Relationships die out & The next generation will scarcely know each other, such is life. Do you ever see Minnie? Maggie said she heard that she was moving into a smaller house. It is 38 years today since Emily Davison died, how time flies! Isn't the cost of living getting terrible? There is no hope of any reduction as long as work men keep asking for more money. We've been born too soon, when I think of how hard I had to work in my young days for a few shillings, today they are getting as many pounds & giving little labour in return. In general I don't think the working publics are playing fair, I wouldn't like to have to employ any one today. Now I must stop this rambling & close with my love & best wishes for your health & comfort.

From Cousin

Jessie Bilton

Remembering Emily

We have to free half of the human race, the women, so that they can help to free the other half.

Emmeline Pankhurst (1858-1928)

THE NINETIETH TRIBUTE anniversary to Emily Wilding Davison, in 2003, brought together the descendants of her grandparents, the Andersons, Caisleys and Davisons of the border parishes of Northumberland.

It became a platform to share the stories handed down to them, and set in motion a number of projects, including the restoration of the family grave in 2008. In June 2013, we will celebrate the centenary of Emily's death and hand on the torch to the next generation.

If there is one thing that I have learnt from a decade of research, is that we must always seek the truth for ourselves. One question in a weekly newspaper started this roller-coaster of discovery, and that was this: 'Are you related to Emily?'

It was asked at the right time, in the right place, and the silent minority came flocking to my door. The secret suffrage history of a small market town in Northumberland can now be revealed – the answers were there, but no one had looked for them in the right place. Family history is often derided for not being 'proper history'. Well, we here in Northumberland have proved that it has a value and a story to tell.

Emily's family members put their trust in me because I was known to them as a local

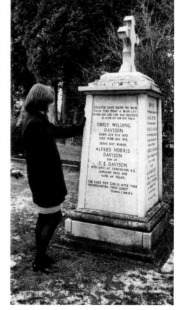

This is the Davison family grave before it was restored. Alice Lewis is pictured: she is descended from Isabella Caisley, who married Robert Wood; Isabella was the eldest daughter of John and Elizabeth Caisley, and the aunt of Emily Wilding Davison. (Woods/Guidepost Archives)

genealogist, with no axe to grind and most importantly no hidden agendas. The journey that we travelled together has been inspirational – gradually, we began to peel away the 'urban myths' that had taken root in our national consciousness about the Epsom protest. Genealogy techniques became the key that opened doors for me, doors which had been firmly closed against the outside world for almost a century. Now the truth is out: Emily did not go to Epsom with the intention of committing suicide; she went as the representative of the women of Northumberland.

Today, at last, she is going to be recognised. A plaque is shortly to be placed at Tattenham Corner, and a whole raft of events (under the heading 'Emily Inspires') are being put in place in 2013. But, most importantly of all, we have given back to Emily her 'Northern Heritage'.

LEFT June 2008, and the grave restoration weekend. This picture was taken by Geoffrey Davison when Cynthia, my sister-in-law and a fellow genealogist, and I were showing him the gravestone. The stone, which had been re-discovered beside the lychgate, marked the burial site of John Anderson (who died in 1827), Emily's great-grandfather; John was the father of Mary Davison (*née* Anderson), who in turn was the mother of Charles Edward Davison, Emily's father. Since this photo was taken, health and safety laws have ruled that it should be laid flat. (Davison Archive of Australia)

RIGHT June 2008, again at the grave restoration weekend. Here, Geoffrey Davison of Australia, the titular head of the Emily Wilding Davison family line, is shown speaking. The scarf draped around the podium belonged to Emily. It is in the suffrage colours, and was purchased at auction by Barbara Gorna. Since this picture was taken, it has been loaned to the Houses of Parliament's display. (Davison Archive of Australia)

June 2003, and the ninetieth anniversary tribute weekend: Geoffrey Davison, Maureen Howes and Rodney Bilton. (Courtesy of the Davison/Caisley families)

The late Moira Rogers of Bristol with two re-enactment suffragettes at the 2003 weekend. Moira was the granddaughter of Isabella Georgina Bayly (*née* Davison) who, when she married, went to live in a castle in Tipperary. After a long search for this branch of the family, I placed an article about Emily Wilding Davison asking for her relatives to contact me in the *Townswomen's Magazine*. Moira was a member of Henleaze Townswomen's Guild near her home, and saw the article. She was a delightful lady, and told me of the letter she had from one of her uncles when they learned that the woman hiding in the Houses of Parliament was their Aunt Emily – one filled with amusement. (Courtesy of the Davison/Caisley families)

A display case at the 2003 weekend. The family members arrived with carrier bags filled with family archive material no one had seen before. A local librarian volunteered to sit and record what they had brought, and then placed them in the display cases for safety. We had no idea what anyone would bring: it was like opening Christmas presents as we greeted the long-lost relatives and introduced them to their distant cousins. The book standing up on the top shelf was Emily's *Pitman Shorthand Tutorial*, which she used to teach young women how to do shorthand. Inside it was signed 'Emily W. Davison, Tottenham Polytechnic, 1900'. It was truly an amazing day. (Courtesy of the Davison/Caisley families)

The christening gown of Emily Wilding Davison (courtesy of the late Mrs Renee Bevan of Hepscott). It had been carefully laundered and ironed by her neighbour for her and then brought to be displayed. There is an indelible laundry mark on the inside seam, saying 'Davison'. The two gowns she brought are hand-stitched: the boys had the plainer one (which is not on display), and the girls had a more delicately embroidered one (shown here). (Courtesy of the Davison/Caisley families)

The 2003 tribute display. Terry and Maureen Howes, and the Caisley/Davison family archive display boards. (Courtesy of the Davison/Caisley families)

The 2003 weekend: Town Hall display. Bill Bevan, Maureen Howes and Cynthia Claypole, genealogists. (Courtesy of the Davison/Caisley families)

The 2003 weekend: Town Hall display. Moira Hughes of Mooroolbark, Australia, one of William Seton Davison's descendants, and Maureen Howes. (Courtesy of the Davison/Caisley families)

The 2003 tribute: family archive display and timeline. (Courtesy of the Davison/Caisley families)

Geoffrey Davison of Australia, the titular head of Emily Wilding Davison's family line, with Maureen Howes. (Courtesy of the Davison/Caisley families)

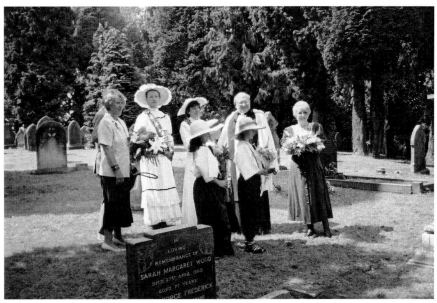

St Mary's churchyard: a re-enactment group, with Longhorsley schoolchildren dressed as suffragettes, County Councillor Dorothy Luke and the Revd McClain. (Courtesy of the Davison/Caisley families)

Re-enactment suffragettes in St Mary's churchyard. (Courtesy of the Davison / Caisley families)

2003 tribute weekend: Town Hall display. Bill Bevan and Rodney and Mrs Bilton. (Courtesy of the Davison / Caisley families)

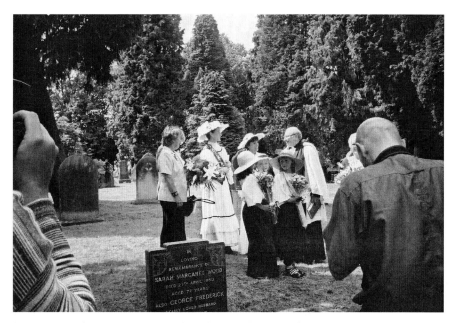

St Mary's churchyard: Longhorsley schoolchildren. (Courtesy of the Davison/Caisley families)

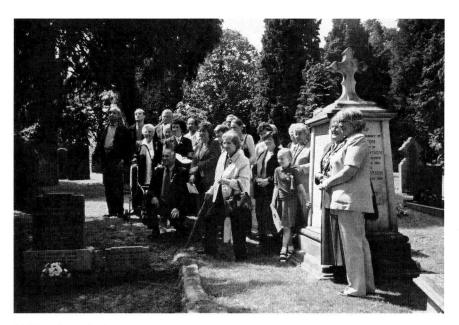

2003 weekend: Caisley and Davison descendants at Emily Wilding Davison's grave. (Courtesy of the Davison/Caisley families)

2003 weekend: Geoffrey Davison with two re-enactment suffragettes. (Courtesy of the Davison/Caisley families)

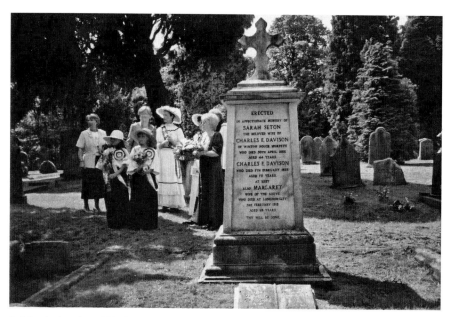

St Mary's churchyard: Emily Wilding Davison's grave, with schoolchildren, Dorothy Luke and re-enactment suffragettes. (Courtesy of the Davison/Caisley families)

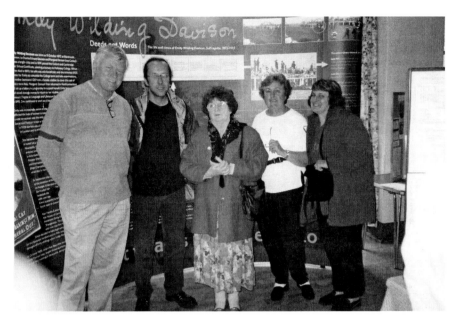

Rodney Bilton (Caisley/Bilton descendant), Bill Bevan (Caisley/Wilkinson descendant), Maureen Howes, Moira Hughes and her sister, Diane (William Seton Davison descendants). (Courtesy of the Davison/Caisley families)

A Suffrage Timeline

1865	1st Women's Suffrage Society formed
1870	Women's Suffrage Bill – passed at the second reading in the House of Commons – is rejected in Committee
1872	Mona Taylor becomes involved in local suffrage movement
1897	National Union of Women's Suffrage Societies (NUWSS) is founded by Millicent Garrett Fawcett
1900	Mona Taylor established NUWSS in Newcastle
1903	Women's Social and Political Union (WSPU) formed by Emmeline Pankhurst. 'DEEDS NOT WORDS' is their motto
1906	Liberals come to power (PM's support of women's suffrage was opposed by his cabinet)
1906	The term 'Suffragette' first used by national press; WSPU disrupt the state opening of Parliament
1907	Suffragette militancy increased; Women's Enfranchisement Bill thrown out by House of Commons
1908	Asquith became Prime Minister and expresses his opposition to votes for women. First window-breaking campaign begins. Mona Taylor forms WSPU unit in Newcastle
1909	'Political prisoner' status denied to suffragettes: they are imprisoned as 'common felons'. The result: hunger strikes. Force-feeding programme introduced
1910	Conciliation Bill (to allow women limited franchise) defeated. WSPU met with increased police brutality
1911	Following failure of the Conciliation Bill, 223 people arrested during WSPU window-breaking campaign
1912	Royal Mail letter boxes set alight. Miners recruited to protect suffragettes and WSPU offices in Glasgow following attacks by male undergraduates

19-13	The notorious 'Cat and Mouse Act' passed as a result of martyrdom fears
19-14	The outbreak of First World War. Women's Movement ceased militancy in order to support the war effort
19-18	First World War ends; Representation of the People Act gives women over thirty the vote
19-18	General election: seventeen women stood. One was elected, but never took up her seat
19-19	Lady Astor becomes the first female MP
1923	Lady Astor becomes the first woman to introduce a Bill that became legislation
1924	Margaret Bondfield becomes the first woman to hold ministerial office
1928	Voting age for women lowered to twenty-one (the same as men)
1929	Margaret Bondfield becomes the first female cabinet member
1936	Jarrow March, accompanied by the Rt. Hon. Ellen Wilkinson, MP
1939	The outbreak of the Second World War
1945	Second World War ends
1964	Harriet Slater became first woman whip
1969	Voting age for both men and women lowered to eighteen
1979	Margaret Thatcher becomes the first female Prime Minister
1992	The Rt. Hon. Betty Boothroyd becomes the first woman to be elected speaker in the House of Commons
1997	General election saw the largest number of female MPs elected: 120
1998	The Rt. Hon. Anne Taylor became first female chief whip
200-1	118 women elected as MPs at the general election
	Since 1918, a total of 252 women (6 per cent) have been elected as MPs to the House of Commons

FAMILY TIMELINE

1863	The Davisons bought Winton House at auction in the Town Hall
1864	Margaret Caisley in residence at Winton House with the family as a live-in carer and nursery maid for the children. They celebrate the baptism of John Anderson Davison on 16 October 1864 in St Mary's church
1865	Charles Edward Davison elected as a member of St Mary's Four and Twenty, serving the parish as a churchwarden
1866	Margaret Caisley employed as a housekeeper to Charles Edward Davison. Sarah Seton Davison, wife to Charles, died
1868	February: Letitia, the first child of Margaret and Charles, born and baptised in County Durham
August	Margaret and Charles married
1869	Alfred Norris, second child of Margaret and Charles, born at Winton House, Morpeth
1872	Emily Wilding, third child of Margaret and Charles, born in Blackheath, London
	Winton House sold for £2,000
1874	Ethel Henrietta, fourth child of Margaret and Charles, born (died in 1880)
1891	Census shows Charles Edward Davison in London with Margaret, Letitia and Emily
1893	Charles Edward Davison died in London. Margaret, the sole beneficiary, receives £102
1893	Despite financial problems, Emily returns to college, funded by her Aunt Dorothy (Caisley)
1895	Emily completes Oxford course, attaining a First Class Honours Degree in Language and Literature
1895	Letitia marries Frederick De Baecker, witnessed by Emily
1895/99	Emily teaching in Birmingham and West Worthing
1901	National Census shows Emily as 'live in' governess in Spratton. Margaret Davison in residence at Longhorsley, Northumberland.
	Later in the year, Emily teaching night-school classes to young women wishing to become secretaries. (In 2002, I was privileged

	to hold her *Pitman Shorthand Tutorial* book, signed 'Emily W. Davison, Tottenham Polytechnic, 1900'. Caisley/Shaw family papers)
1903	Emily spends Christmas in Dunkirk with her sister and family
1917	Margaret Davison's New Year's greeting to the WSPU is published in their magazine, sharing her continued strong support for the movement and hopes for their future
1918	Alfred Norris Davison (Emily's full brother) dies in Vancouver, Canada. Ten days later, Margaret Davison (Emily's mother) dies in Longhorsley
1934	Following a derisive newspaper article, Letitia writes to the editor from Paris in her sister's defence
1939	Following outbreak of the Second World War, Letitia writes that she hopes family members will tend to the family grave in her enforced absence
1943	Letitia dies in Paris

EMILY'S YEARS AS SUFFRAGETTE TIMELINE

1906	Emily joins WSPU
	While some suffragettes chain themselves to railings in Downing Street, Emily chose Westminster Abbey
1908	Emily is chief steward at WSPU meetings; WSPU demonstration in Hyde Park. Women attend in their thousands
1909	Emily extremely active within WSPU; arrested on a number of occasions in Manchester, London and Newcastle. During imprisonment, she went on hunger strike and was force-fed
1910	Emily hired by WSPU as a paid organiser
1910/11	Emily hides in the House of Commons on three separate occasions
1911	Emily sentenced to six months' imprisonment for setting fire to Royal Mail letter boxes. She goes on hunger strike on two occasions
1912	Emily arrested in Aberdeen for assaulting a church minister she mistook for Lloyd George
1913	Emily unsuccessfully applies for a number of posts in order to support herself

JUNE 1913 TIMELINE

4th
: Emily's dramatic protest results in her sustaining serious injuries after she was struck by the King's horse during the Epsom Derby

5th
: Emily treated in Epsom Cottage Hospital for 'concussion of the brain'

6th
: Her condition worsens; she undergoes surgery and her family is informed

7th
: Visited by suffragettes. Her sister and later Captain Henry Jocelyn Davison arrive to represent the family's interests

8th
: Emily dies at 4.30 p.m., with no family present

9th
: WSPU proposes a public funeral and burial to take place in Morpeth

10th
: Inquest at Epsom Courthouse; verdict 'Death by Misadventure'

14th
: Emmeline Pankhurst arrested under The Cat and Mouse Act as she leaves home to attend Emily's funeral. People pay their respects by standing at mainline stations during the coffin's rail journey to Morpeth

15th
: Coffin arrives in Morpeth and funeral cortège is watched by huge crowds as it travels from the railway station to St Mary's for the burial